Thoughts on Art and Life

By

Leonardo da Vinci

A TABLE OF CONTENTS

INTRODUCTION

* *

*

The long obscurity of the Dark Ages lifted over Italy, awakening to a

national though a divided consciousness. Already two distinct

tendencies were apparent. The practical and rational, on the one hand,

was soon to be outwardly reflected in the burgher-life of Florence and

the Lombard cities, while at Rome it had even then created the civil

organization of the curia. The novella was its literary triumph. In

art it expressed itself simply, directly and with vigour. Opposed to

this was the other great undercurrent in Italian life, mystical,

religious and speculative, which had run through the nation from the

earliest times, and received fresh volume from mediaeval Christianity,

encouraging ecstatic mysticism to drive to frenzy the population of its

mountain cities. Umbrian painting is inspired by it, and the glowing

words of Jacopone da Todi expressed in poetry the same religious

fervour which the life of Florence and Perugia bore witness to in

action.

Italy developed out of the relation and conflict of these two forces

the rational with the mystical. Their later union in the greater men

was to {x} form the art temperament of the Renaissance. The practical

side gave it the firm foundation of rationalism and reality on which it

rested; the mystical guided its endeavour to picture the unreal in

3

terms of ideal beauty.

The first offspring of this union was Leonardo. Since the decay of ancient art no painter had been able to fully express the human form, for imperfect mastery of technique still proved the barrier. Leonardo was the first completely to disengage his personality from its constraint, and make line express thought as none before him could do. Nor was this his only triumph, but rather the foundation on which further achievement rested. Remarkable as a thinker alone, he preferred to enlist thought in the service of art, and make art the handmaid of beauty. Leonardo saw the world not as it is, but as he himself was. He viewed it through the atmosphere of beauty which filled his mind, and tinged its shadows with the mystery of his nature. To all this, his birthright as a painter, a different element was added. A keen desire for knowledge, guiding his action in life, spurred him onward. Conscious of this dominant impulse, he has fancifully described himself in a Platonic allegory. He had passed beneath overhanging cliffs on his way to a great cavern. On bended knees, peering through its darkness, fear and desire had overwhelmed him,--fear for the menacing darkness of the cavern; and desire {xi} to ascertain if there were wonders therein.

From his earliest years, the elements of greatness were present in Leonardo. But the maturity of his genius came unaffected from without. He barely noticed the great forces of the age which in life he encountered. After the first promise of his boyhood in the Tuscan hills, his youth at Florence had been spent under Verrocchio as a

master, in company with those whose names were later to brighten the pages of Italian art. He must then have heard Savonarola's impassioned sermons, yet, unlike Botticelli, remained dumb to his entreaties. He must have seen Lorenzo the Magnificent. But there was little opening in the Medicean circle for the young painter, who had first to gain fame abroad. The splendour of Milan under Il Moro, then the most brilliant court in Europe, attracted him. He went there, proclaiming his ability, in a remarkable letter, to accomplish much, but desiring chiefly to erect a great monument to the glory of the Sforza. He spent years at that court, taken up by his different ventures,--painting, sculpture, engineering, even arranging festivities--but his greater project was doomed to failure, enmeshed in the downfall of Ludovico. Even to this he remained impassive. "Visconti dragged to prison, his son dead, ... the duke has lost his state, his possessions, his liberty, and has finished nothing he undertook," was his only comment on his patron's end, written on the {xii} margin of a manuscript. After the overthrow of the Duke of Milan, began his Italian wanderings. At one time he contemplated entering the service of an Oriental prince. Instead, he entered that of Caesar Borgia, as military engineer, and the greatest painter of the age became inspector of a despot's strongholds. But his restless nature did not leave him long at this. Returning to Florence he competed with Michelangelo; yet the service of even his native city could not retain him. His fame had attracted the attention of a new patron of the arts, prince of the state which had conquered his first master. In this his last venture, he forsook Italy, only to die three years later at Amboise, in the castle of the French king.

5

The inner nature of Leonardo remained as untouched by the men he encountered as by the events which were then stirring Europe. Alone, he influenced others, remaining the while a mystery to all. The most gifted of nations failed to understand the greatest of her sons. Isabella d'Este, the first lady of her time, seeking vainly to obtain some product of his brush, was told that his life was changeful and uncertain, that he lived for the day, intent only on his art. His own thoughts reveal him in another light. "I wish to work miracles," he wrote. And elsewhere he exclaimed, "Thou, O God, sellest us all benefits, at the cost of our toil.... As a day well spent makes sleep {xiii} seem pleasant, so a life well employed makes death pleasant. A life well spent is long."

Leonardo's views of aesthetic are all important in his philosophy of life and art. The worker's thoughts on his craft are always of interest. They are doubly so when there is in them no trace of literary self-consciousness to blemish their expression. He recorded these thoughts at the instant of their birth, for a constant habit of observation and analysis had early developed with him into a second nature. His ideas were penned in the same fragmentary way as they presented themselves to his mind, perhaps with no intention of publishing them to the world. But his ideal of art depended intimately, none the less, on the system he had thrown out seemingly in so haphazard a manner. His method gives to his writings their only unity. It was more than a method: it was a permanent expression of his

own life, which aided him to construct a philosophy of beauty characteristic of the new age.

He had searched to find a scientific basis for art, and discovered it in the imitation of nature, based on rational experience. This idea was, in part, Aristotelian, imbibed with the spirit of the time; though in the ordinary acceptance of the word Leonardo was no scholar, least of all a humanist. His own innovation in aesthetic was in requiring a rational and critical experience as a necessary {xiv} foundation, the acquisition of which was to result from the permanent condition of the mind. He had trained his own faculties to critically observe all natural phenomena: first try by experience, and then demonstrate why such experiment is forced to operate in the way it does, was his advice. The eye, he gave as an instance, had been defined as one thing; by experience, he had found it to be another.

But by imitation in art, Leonardo intended no slavish reproduction of nature. When he wrote that "the painter strives and competes with nature," he was on the track of a more Aristotelian idea. This he barely developed, using nature only partly in the Stagirite's sense, of inner force outwardly exemplified. The idea of imitation, in fad, as it presented itself to his mind, was two-fold. It was not merely the external reproduction of the image, which was easy enough to secure. The real difficulty of the artist lay in reflecting inner character and personality. It was Leonardo's firm conviction that each thought had some outward expression by which the trained observer was able to recognize it. Every man, he wrote, has as many movements of the body

7

as of varieties of ideas. Thought, moreover, expressed itself

outwardly in proportion to its power over the individual and his time

of life. By thus employing bodily gesture to represent feeling and

idea, the painter could affect the spectator whom he {xv} placed in the

presence of visible emotion. He maintained that art was of slight use

unless able to show what its subject had in mind. Painting should aim,

therefore, to reproduce the inner mental state by the attitude assumed.

This was, in other words, a natural symbolism, in which the symbol was

no mere convention, but the actual outward projection of the inner

condition of the mind. Art here offered an equation of inward purpose

and outward expression, neither complete without the other.

Further than this, influenced by Platonic thought, Leonardo's

conception of painting was, as an intellectual state or condition,

outwardly projected. The painter who practised his art without

reasoning of its nature was like a mirror unconsciously reflecting what

was before it. Although without a "manual act" painting could not be

realized, its true problems--problems of light, of colour, pose and

composition, of primitive and derivative shadow--had all to be grasped

by the mind without bodily labour. Beyond this, the scientific

foundation in art came through making it rest upon an accurate

knowledge of nature. Even experience was only a step towards attaining

this. "There is nothing in all nature without its reason," he wrote.

"If you know the reason, you do not need the experience."

In the history of art, as well, he urged that nature had been the test

of its excellence. A {xvi} natural phenomenon had brought art into

8

existence. The first picture in the world, he remarked in a happy

epigram, had been "a line surrounding the shadow of a man, cast by the

sun on the wall." He traced the history of painting in Italy during

its stagnation after the decay of ancient art, when each painter copied

only his predecessor, which lasted until Giotto, born among barren

mountains, drew the movements of the goats he tended, and thus advanced

farther than all the earlier masters. But his successors only copied

him, and painting sank again until Masaccio once more took nature as

his guide.

A quite different and combative side to Leonardo's aesthetic, which

forced him to state the broad principles of art, appears in his attacks

on poetry and music as inferior to painting. In that age of humanistic

triumph, literature had lorded it over the other arts in a manner not

free from arrogance. There was still another cause for his onslaught

on poetry. Leonardo resented the fact that painters, who were rarely

men of education, had not defended themselves against the slurs cast on

their art. His counter attack may have been intended to hide his own

small scholarship. It served another end as well. His conception of

the universal principles of beauty was made clear by this defence. His

first principle stated broadly that the most useful art was the one

which could most easily be communicated. {xvii} Painting was

communicable to all since its appeal was made to the eye. While the

painter proceeded at once to the imitation of nature, the poet's

instruments were words which varied in every land. He took the

Platonic view of poetry as a lying imitation, removed from truth. He

called the poet a collector of other men's wares, who decked himself in

their plumage. Where poetry presented only a shadow to the

imagination, painting offered a real image to the eye; and the eye, as

the window of the soul through which all earthly beauty was revealed,

the sight, he exclaimed, which had discovered navigation, which had

impelled men to seek the West, was the noblest of all the senses.

Painting spoke only by what it accomplished, poetry ended in the very

words with which it sang its own praises. If, then, poets called

painting dumb poetry, he could retort by dubbing poetry blind painting.

In common with his successors, Leonardo could not escape from this

fallacy, which, in overlooking all save descriptive verse, was destined

to burden aesthetic until demolished by Lessing.

It was the opinion of Leonardo that the temporary nature of music

caused its inferiority to painting. Although durability was in itself

no absolute test,--else the work of coppersmiths would be the highest

art,--yet in any final scale, permanence could not altogether be

disregarded. Music perished in the very act of its creation, {xviii}

while painting preserved the beautiful from the hand of time. "Helen

of Troy, gazing in a mirror, in her old age, wondered how she had twice

been ravished." Mortal beauty would thus vanish, if it were not

rescued by art from destroying age and death.

Leonardo contrasted painting with sculpture, for he had practised both,

and thought himself peculiarly qualified to judge their merit. He

considered the former the nobler art of the two, for sculpture involved

bodily toil and fatigue, while by its very nature it lacked perspective

and atmosphere, colour, and the feeling of space. Painting, on the

other hand, caused by an illusion, was in itself the result of deeper thought. An even broader test served to convince him of its final superiority. That art was of highest excellence, he wrote, which possessed most elements of variety and universality. Painting contained and reproduced all forms of nature; it made its appeal by the harmonious balance of parts which gratified all the senses. By its very duality it fulfilled the highest purpose. The painter was able to visualize the beauty which enchanted him, to bring to reality the fancy of his dreams, and give outward expression to the ideal within.

The genius of Leonardo as a painter came through unfolding the mystery of life. Like Miranda, he had gazed with wonder at the beauty of the world. "Look at the grace and sweetness {xix} of men and women in the street," he wrote. The most ordinary functions of life and nature amazed him most. He observed of the eye how in it form and colour, and the entire universe it reflected, were reduced to a single point. "Wonderful law of nature, which forced all effects to participate with their cause in the mind of man. These are the true miracles!" Elsewhere he wrote again: "Nature is full of infinite reasons which have not yet passed into experience." He conceived it to be the painter's duty not only to comment on natural phenomena as restrained by law, but to merge his very mind into that of nature by interpreting its relation with art. Resting securely on the reality of experienced truth, he felt the deeper presence of the unreal on every side. In the same way that he visualized the inner workings of the mind, his keen imagination aided him to make outward trifles serve his desire to find mysterious beauty everywhere. Oftentimes, in gazing on some ancient,

11

time-stained wall, he describes how he would trace thereon landscapes, with mountains, rivers and valleys. The whole world was full of a mystery to him, which his work reflected. The smile of consciousness, pregnant of that which is beyond, illumines the expression of Mona Lisa. So, too, in the strange glance of Ann, of John the Baptist, and of the Virgin of the Rocks, one realizes that their thoughts dwell in another world.

{xx}

Leonardo had found a refuge in art from the pettiness of material environment. Like his own creations, he, too, had learned the secret of the inner life. The painter, he wrote, could create a world of his own, and take refuge in this new realm. But it must not be one of shadows only. The very mystery he felt so keenly had yet to rest on a real foundation; to treat it otherwise would be to plunge into mere vapouring. Although attempting to bridge the gulf which separated the real from the unreal, he refused to treat the latter supernaturally. That mystery which lesser minds found in the occult, he saw in nature all about him. He denied the existence of spirits, just as he urged the foolishness of the will-o'-the-wisps of former ages,--alchemy and the black art. In one sentence he destroyed the pretensions of palmistry. "You will see," he wrote, "great armies slaughtered in an hour's time, where in each individual the signs of the hands are different."

His art took, thus, its guidance in realism, its purpose in

spirituality. The search for truth and the desire for beauty were the twin ideals he strove to attain. The keenness of this pursuit saved him from the blemish of egoism which aloofness from his surroundings would otherwise have forced upon him. For his character presented the anomaly, peculiar to the Renaissance, of a lofty idealism coupled in action with {xxi} irresponsibility of duty. He stood on a higher plane, his attitude toward life recognizing no claims on the part of his fellowmen. In his desire to surpass himself, fostered by this isolation of spirit and spurred on by the eager wish to attain universal knowledge, he has been compared to Faust; but the likeness is only half correct. He was not blind to the limitations which encompassed him, his very genius making him realize their bounds. Of the ancients he said that in attempting to define the nature of the soul, they sought the impossible. He wrote elsewhere, "It is the infinite alone that cannot be attained, for if it could it would become finite."

In Leonardo's personality was reflected both the strength and weakness of Renaissance Italy. So, to know him, it is necessary to understand the Italy of that age. Its brilliancy, its universality, its desire for beauty, are but one side of the medal. On its reverse, Italy lacked the solid vigour of a national purpose. The discord of political disunion, reacting on art, laid bare great weakness in the want of any constructive direction, toward which the strength of the Renaissance could aim. The energy was there, whether finding an outlet in statecraft or in discovery, in art or in letters. But it laboured for no common end; there was internal unity of force and method, but

external divergence of purpose. The tyranny of petty despots could provide no adequate ideal toward {xxii} which to aim. No ruler, and no city save Venice, could long symbolize the nation's patriotism. Venetian painters alone glorified the state in their work, and thus felt the living force of a national ambition which raised them above themselves. But elsewhere there was little to inspire that devotion for a common country necessary as a background to sustain the greatest work. Hence Italian art, so living within certain limits, remained stunted beyond these. The conviction that art existed in order to express ideal beauty, that its main purpose was to please the eye and the senses in spite of the result attained, proved inadequate compensation for all that had been withdrawn. The art ideal tended more and more to become a conscience and a purpose in itself, an inward impulse for action and an outward goal.

The artist's real greatness will depend at all times on his qualities as a representative. His true merit will arise from giving expression in ideal terms to his nation and to his age. In so far as he has been able to do this and the spirit of his country is reflected in his work, in so far as he has represented what is best therein and most enduring, he will have achieved greatness. Not that this is always, or even often, a conscious expression. It is unfair reading to search for deep thought in the work of either painter or poet. Neither art {xxiii} offers the best medium to convey the abstractions of the mind, since each has its own method of expression, independent of pure reason. But painter and poet, in the degree they attain greatness, express more

than themselves. Ariosto, intent only to amuse, reflects with playful wit and skepticism the splendid luxury and joy of living in Renaissance court life. The care with which he chiselled each line proves that his real seriousness and conscience lay in his artistic purpose. Without Ariosto's wit, Paolo Veronese depicted a similar side in painting, though his Venetian birthright made him celebrate the glory of the Republic. Poet and painter alike expressed far more than either could know. If such a test be applied to the artists of the Renaissance, each in turn will respond to it,--just as the weakness of the later Bolognese as a school is that, beyond a certain technical merit, they meant and represented so little. But the noblest painters,--Michelangelo and Raphael, Titian and Leonardo,--in addition to possessing the solid grasp of technical mastery, reflected some aspect of their nation's life and civilization. In Michelangelo was realized the grandeur of Italy struggling vainly against crushing oppression. He expressed that which was highest in it, reflecting the loftiest side of its idealism mingled with deep pessimism in his survey over life; for, wrapped in austerity, he saw mankind in heroic terms of sadness. Raphael, on the {xxiv} other hand, found only beautiful sweetness everywhere. The tragedies of life failed to touch the young painter, who blotted from view all struggle and sorrow, and, in spite of the misery which had befallen his nation, could still rejoice in the sensuous beauty of the world. There was another side to the Renaissance, dependent neither on beauty nor heroic grandeur, yet sharing in both through qualities of its own. Titian, who painted the living man of action, the man of parts, susceptible alike to the appreciation of ideal beauty and heroic impulse, but guided withal by

15

expediency, reflected this more practical aspect of life. In his portraiture he expressed the statecraft for which Italians found opportunity beyond the Alps, since in Italy it was denied them; and Titian found even Venice too narrow for the scope of his art.

But before Titian, before Raphael, before Michelangelo, Leonardo reflected the rationalism and the mystery, the subtlety and the philosophical speculation, of the age. To find in his work only the individual thought of genius would be to mistake, perhaps, its most important side; for the expression of his mind, both by its brilliancy and its limitations, is typical of the spirit of his time. The Italian Renaissance was reflected in him as rarely a period has been expressed in the life-work of a single man. He represented its union of practice and theory, of thought placed in the {xxv} service of action. He summed up its different aspects in his own individuality. Intellectually, he represented its many-sidedness attained through penetration of thought, and a keenness of observation, profiting from experience, extended into every sphere. As an artist he possessed a vigour of imagination from which sprang his power of creating beauty. But, in spite of his practical nature, he remained a dreamer in an age which had in it more of stern reality than of golden dreams. His very limitations, his excess of individualism, his want of long-continued concentration, his lack of patriotism, his feeling of the superiority of art to nationality, are all characteristic of Renaissance Italy.

The union in Leonardo of reality to mystery has often been shared by genius in other fields. His own peculiar greatness sprang from

16

expressing in art the apparent contradiction of attaining the world of mystery through force of reality. Like Hamlet, it was the union of the real with the unreal which appealed to him, of the world as he saw it and the world as he imagined it to be. It was but another expression of the eternal ideal of truth and beauty.

L. E.

American Embassy

 London, 1906

{3}

I

THOUGHTS ON LIFE

 * *

 *

[Sidenote: Of the Works of Leonardo]

Begun at Florence in the house of Piero di Braccio Martelli, on the 22d day of March, 1508; and this is to be a collection without order, taken

from many papers which I have copied here, hoping to arrange them later, each in its place, according to the various subjects treated. And I think that before I shall have finished this work, it will be necessary for me to repeat the same thing many times over; so, O reader, blame me not, because the subjects are many, and memory cannot retain them and say: This I will not write because I have already written it; and if I did not wish to fall into this error it would be necessary, every time that I wished to copy something, in order not to repeat myself, to read over all the preceding matter, all the more so since the intervals are long between one time of writing and another.

[Sidenote: His Thirst after Knowledge]

2.

Not louder does the tempestuous sea bellow when the north wind strikes its foaming waves between Scylla and Charybdis; nor Stromboli nor Mount Etna when the sulphurous flames, {4} shattering and bursting open the great mountain with violence, hurl stones and earth through the air with the flame it vomits; nor when the fiery caverns of Mount Etna, spitting forth the element which it cannot restrain, hurl it back to the place whence it issued, driving furiously before it any obstacle in the way of its vehement fury ... so I, urged by my great desire and longing to see the blending of strange and various shapes made by creating nature, wandered for some time among the dark rocks, and came to the entrance of a great cave, in front of which I long stood in

astonishment and ignorance of such a thing. I bent my back into an

arch and rested my left hand on my knee, and with my right hand shaded

my downcast eyes and contracted eyebrows. I bent down first on one

side and then on the other to see whether I could perceive anything,

but the thick darkness rendered this impossible; and after having

remained there some time, two things arose within me, fear and

desire,--fear of the dark and threatening cave, desire to see whether

there were anything marvellous within.

3.

I discover for man the origin of the first and perhaps of the second

cause of his being.

[Sidenote: Leonardo's Studies]

4.

Recognizing as I do that I cannot make use of {5} subject matter which

is useful and delightful, since my predecessors have exhausted the

useful and necessary themes, I shall do as the man who by reason of his

poverty arrives last at the fair, and cannot do otherwise than purchase

what has already been seen by others and not accepted, but rejected by

them as being of little value. I shall place this despised and

rejected merchandise, which remains over after many have bought, on my

poor pack, and I shall go and distribute it, not in the big cities, but in the poor towns, and take such reward as my goods deserve.

[Sidenote: Vain Knowledge]

5.

All knowledge which ends in words will die as quickly as it came to life, with the exception of the written word: which is its mechanical part.

6.

Avoid studies the result of which will die together with him who studied.

[Sidenote: Value of Knowledge]

7.

The intellect will always profit by the acquisition of any knowledge whatsoever, for thus what is useless will be expelled from it, and what is fruitful will remain. It is impossible either to hate or to love a thing without first acquiring knowledge of it.

{6}

8.

Men of worth naturally desire knowledge.

9.

It is ordained that to the ambitious, who derive no satisfaction from the gifts of life and the beauty of the world, life shall be a cause of suffering, and they shall possess neither the profit nor the beauty of the world.

[Sidenote: On his Contemners]

10.

I know that many will say that this work is useless, and these are they of whom Demetrius said recked no more of the breath which made the words proceed from their mouth, than of the wind which proceeded from their body,--men who seek solely after riches and bodily satisfaction, men entirely denuded of that wisdom which is the food and verily the wealth of the soul; because insomuch as the soul is of greater value than the body, so much greater are the riches of the soul than those of

the body. And often when I see one of these take this work in his hand, I wonder whether, like a monkey, he will not smell it and ask me if it is something to eat.

[Sidenote: On the Vulgar]

11.

Demetrius used to say that there was no difference between the words and the voice of the {7} unskilled ignorant and the sounds and noises of a stomach full of superfluous wind. And it was not without reason that he said this, for he considered it to be indifferent whence the utterance of such men proceeded, whether from their mouth or their body; both being of the same substance and value.

12.

I do not consider that men of coarse and boorish habits and of slender parts deserve so fine an instrument nor such a complicated mechanism as men of contemplation and high culture. They merely need a sack in which their food may be held and whence it may issue, since verily they cannot be considered otherwise than as vehicles for food, for they seem to me to have nothing in common with the human race save the shape and the voice; as far as the rest is concerned they are lower than the beasts.

13.

Knowledge of the past and of the places of the earth is the ornament and food of the mind of man.

[Sidenote: Knowledge the supreme Good]

14.

Cornelius Celsus: Knowledge is the supreme good, the supreme evil is physical pain. We are composed of two separate parts, the soul and the the body; the soul is the greater of these two, the body the lesser. Knowledge appertains to the {8} greater part, the supreme evil belongs to the lesser and baser part. Knowledge is an excellent thing for the mind, and pain is the most grievous thing for the body. Just as the supreme evil is physical pain, so is wisdom the supreme good of the soul, that is to say of the wise man, and no other thing can be compared with it.

[Sidenote: Life and Wisdom]

15.

In the days of thy youth seek to obtain that which shall compensate the losses of thy old age. And if thou understandest that old age is fed with wisdom, so conduct thyself in the days of thy youth that sustenance may not be lacking to thy old age.

[Sidenote: Praise of Knowledge]

16.

The fame of the rich man dies with him; the fame of the treasure, and not of the man who possessed it, remains. Far greater is the glory of the virtue of mortals than that of their riches. How many emperors and how many princes have lived and died and no record of them remains, and they only sought to gain dominions and riches in order that their fame might be ever-lasting. How many were those who lived in scarcity of worldly goods in order to grow rich in virtue; and as far as virtue exceeds wealth, even in the same degree the desire of the poor man proved more fruitful than that of the rich man. {9} Dost thou not see that wealth in itself confers no honour on him who amasses it, which shall last when he is dead, as does knowledge?--knowledge which shall always bear witness like a clarion to its creator, since knowledge is the daughter of its creator, and not the stepdaughter, like wealth.

[Sidenote: The World]

17.

Bountiful nature has provided that in all parts of the world you will find something to imitate.

18.

[Sidenote: The Beauty of Life]

Consider in the streets at nightfall the faces of men and women when it is bad weather, what grace and sweetness they manifest!

19.

Just as iron which is not used grows rusty, and water putrefies and freezes in the cold, so the mind of which no use is made is spoilt.

[Sidenote: Fruitless Study]

20.

Just as food eaten without appetite is a tedious nourishment, so does study without zeal damage the memory by not assimilating what it absorbs.

21.

Truth was the only daughter of time.

{10}

[Sidenote: In Praise of Truth]

22.

So vile a thing is a lie that even if it spoke fairly of God it would take away somewhat from His divinity; and so excellent a thing is truth that if it praises the humblest things they are exalted. There is no doubt that truth is to falsehood as light is to darkness; and so excellent a thing is truth that even when it touches humble and lowly matters, it still incomparably exceeds the uncertainty and falsehood in which great and elevated discourses are clothed; because even if falsehood be the fifth element of our minds, notwithstanding this, truth is the supreme nourishment of the higher intellects, though not of disorderly minds. But thou who feedest on dreams dost prefer the sophistry and subterfuges in matters of importance and uncertainty to what is certain and natural, though of lesser magnitude.

23.

Obstacles in the way of truth are finally punished.

[Sidenote: Versus Humanists]

24.

I am well aware that not being a literary man the presumptuous will

think that they have the right to blame me on the ground that I am not

a man of letters. Vainglorious people! Know they not that I could

make answer as Marius did to the Roman people, and say: They who make a

{11} display with the labours of others will not allow me mine? They

will say that being unskilled in letters I cannot find true expression

for the matters of which I desire to treat; they do not know that in my

subjects experience is a truer guide than the words of others, for

experience was the teacher of all great writers, and therefore I take

her for guide, and I will cite her in all cases.

25.

Although I may not be able to quote other authors, as they do, I can

quote from a greater and more worthy source, namely, experience,--the

teacher of their masters. They go about swelled with pride and

pomposity, dressed up and bedight, not with their own labour, but with

that of others; and they will not concede me mine. And if they despise

me, who am a creator, far more are they, who do not create but trumpet

abroad and exploit the works of other men, to be blamed.

[Sidenote: Authority]

26.

He who in reasoning cites authority is making use of his memory rather

than of his intellect.

[Sidenote: On Commentators]

27.

Men who are creators and interpreters of nature to man, in comparison

with boasters and exploiters of the works of others, must be judged

{12} and esteemed like the object before the mirror as compared with

its image reflected in the mirror.--one being something in itself, and

the other nothing. Little to nature do they owe, since it is merely by

chance they wear the human form, and but for it I might include them

with herds of cattle.

28.

A well lettered man is so because he is well natured, and just as the cause is more admirable than the effect, so is a good disposition, unlettered, more praiseworthy than a well lettered man who is without natural disposition.

29.

Against certain commentators who disparage the inventors of antiquity, the originators of science and grammar, and who attack the creators of antiquity; and because they through laziness and the convenience of books have not been able to create, they attack their masters with false reasoning.

30.

It is better to imitate ancient than modern work.

[Sidenote: Experience]

31.

Wisdom is the daughter of experience.

32.

Wrongly men complain of experience, which {13} with great railing they accuse of falsehood. Leave experience alone, and turn your lamentation to your ignorance, which leads you, with your vain and foolish desires, to promise yourselves those things which are not in her power to confer, and to accuse her of falsehood. Wrongly men complain of innocent experience, when they accuse her not seldom of false and lying demonstrations.

33.

Experience never errs; it is only your judgements that err, ye who look to her for effects which our experiments cannot produce. Because given a principle, that which ensues from it is necessarily the true consequence of that principle, unless it be impeded. Should there, however, be any obstacle, the effect which should ensue from the aforesaid principle will participate in the impediment as much or as little as the impediment is operative in regard to the aforesaid principle.

34.

Experience, the interpreter between creative nature and the human race, teaches the action of nature among mortals: how under the constraint of necessity she cannot act otherwise than as reason, who steers her helm, teaches her to act.

35.

All our knowledge is the offspring of our perceptions.

{14}

[Sidenote: Origin of Knowledge]

36.

The sense ministers to the soul, and not the soul sense; and where the sense which ministers ceases to serve the soul, all the functions of that sense are lacking in life, as is evident in those who are born dumb and blind.

[Sidenote: Testimony of the Senses]

37.

And if thou sayest that sight impedes the security and subtlety of mental meditation, by reason of which we penetrate into divine knowledge, and that this impediment drove a philosopher to deprive himself of his sight, I answer that the eye, as lord of the senses, performs its duty in being an impediment to the confusion and lies of that which is not science but discourse, by which with much noise and gesticulation argument is constantly conducted; and hearing should do the same, feeling, as it does, the offence more keenly, because it seeks after harmony which devolves on all the senses. And if this philosopher deprived himself of his sight to get rid of the obstacle to his discourses, consider that his discourses and his brain were a party to the act, because the whole was madness. Now could he not have closed his eyes when this frenzy came upon him, and have kept them closed until the frenzy consumed itself? But the man was mad, the discourse insane, and egregious the folly of destroying his eye-sight.

{15}

[Sidenote: Judgement prone to Error]

38.

There is nothing which deceives us as much as our own judgement.

39.

The greatest deception which men incur proceeds from their opinions.

40.

Avoid the precepts of those thinkers whose reasoning is not confirmed by experience.

[Sidenote: Intelligence of Animals]

41.

Man discourseth greatly, and his discourse is for the greater part empty and false; the discourse of animals is small, but useful and true: slender certainty is better than portentous falsehood.

42.

What is an element? It is not in man's power to define the quiddity of the elements, but a great many of their effects are known.

43.

That which is divisible in fact is divisible in potentiality also; but

not all quantities which are divisible in potentiality are divisible in fact.

[Sidenote: Infinity incomprehensible]

44.

What is that thing which is not defined and would {16} not exist if it were defined? It is infinity, which if it could be defined would be limited and finite, because that which can be defined ends with the limits of its circumference, and that which cannot be defined has no limits.

45.

O contemplators of things, do not pride yourselves for knowing those things which nature by herself and her ordination naturally conduces; but rejoice in knowing the purposes of those things which are determined by your mind.

[Sidenote: Insoluble Questions]

46.

Consider, O reader, how far we can lend credence to the ancients who

strove to define the soul and life,--things which cannot be proved;

while those things which can be clearly known and proved by experience

remained during so many centuries ignored and misrepresented! The eye,

which so clearly demonstrates its functions, has been up to my time

defined in one manner by countless authorities; I by experience have

discovered another definition.

[Sidenote: Beauty of Nature's Inventions]

47.

Although human ingenuity may devise various inventions which, by the

help of various instruments, answer to one and the same purpose, yet

{17} will it never discover any inventions more beautiful, more simple

or more practical than those of nature, because in her inventions there

is nothing lacking and nothing superfluous; and she makes use of no

counterpoise when she constructs the limbs of animals in such a way as

to correspond to the motion of their bodies, but she puts into them the

soul of the body. This is not the proper place for this discourse,

which belongs rather to the subject of the composition of animated

bodies; and the rest of the definition of the soul I leave to the minds

of the friars, the fathers of the people, who know all secrets by

inspiration. I leave the sacred books alone, because they are the

supreme truth.

48.

Those who seek to abbreviate studies do injury to knowledge and to love because the love of anything is the daughter of this knowledge. The fervency of the love increases in proportion to the certainty of the knowledge, and the certainty issues from a complete knowledge of all the parts, which united compose the totality of the thing which ought to be loved. Of what value, then, is he who abbreviates the details of those matters of which he professes to render a complete account, while he leaves behind the chief part of the things of which the whole is composed? It is true that impatience, the mother of {18} stupidity, praises brevity, as if such persons had not life long enough to enable them to acquire a complete knowledge of one subject such as the human body! And then they seek to comprehend the mind of God, in which the universe is included, weighing it and splitting it into infinite particles, as if they had to dissect it!

O human folly! dost thou not perceive that thou hast been with thyself all thy life, and thou art not yet aware of the thing which more fully than any other thing thou dost possess, namely, thy own folly? And thou desirest with the multitude of sophists to deceive thyself and others, despising the mathematical sciences in which truth dwells and the knowledge of the things which they contain; and then thou dost busy thyself with miracles, and writest that thou hast attained to the

knowledge of those things which the human mind cannot comprehend, which

cannot be proved by any instance in nature, and thou deemest that thou

hast wrought a miracle in spoiling the work of some speculative mind;

and thou perceivest not that thy error is the same as that of a man who

strips a plant of the ornament of its branches covered with leaves,

mingled with fragrant flowers and fruits. Just as Justinius did when

he abridged the stories written by Trogus Pompeius, who had written

elaborately the noble deeds of his forefathers, which were full of

wonderful beauties of style; and thus {19} he composed a barren work,

worthy only of the impatient spirits who deem that they are wasting the

time which they might usefully employ in studying the works of nature

and mortal affairs. But let such men remain in company with the

beasts; let dogs and other animals full of rapine be their courtiers,

and let them be accompanied with these running ever at their heels! and

let the harmless animals follow, which in the season of the snows come

to the houses begging alms as from their master.

[Sidenote: Nature]

49.

Nature is full of infinite causes which are beyond the pale of

experience.

50.

Nature in creating first gives size to the abode of the intellect (the skull, the head), and then to the abode of the vital spirit (the chest).

[Sidenote: Law of Necessity]

51.

Necessity is the mistress and guide of nature. Necessity is the theme and inventress of nature, her curb and her eternal law.

52.

When anything is the cause of any other thing, and brings about by its movement any effect, {20} the movement of the effect necessarily follows the movement of the cause.

[Sidenote: Of Lightning in the Clouds]

53.

O mighty and once living instrument of creative nature, unable to avail thyself of thy great strength thou must needs abandon a life of tranquillity and obey the law which God and time gave to Nature the

mother. Ah! how often the frighted shoals of dolphins and great tunny

fish were seen fleeing before thy inhuman wrath; whilst thou,

fulminating with swift beating of wings and twisted tail, raised in the

sea a sudden storm with buffeting and sinking of ships and tossing of

waves, filling the naked shores with terrified and distracted fishes.

[Sidenote: The Human Eye]

54.

Since the eye is the window of the soul, the soul is always fearful of

losing it, so much so that if a man is suddenly frightened by the

motion or an object before him, he does not with his hands protect his

heart, the source of all life; nor his head, where dwells the lord of

the senses; nor the organs of hearing, smell and taste. But as soon as

he feels fright it does not suffice him to close the lids of his eyes,

keeping them shut with all his might, but he instantly turns in the

opposite direction; and still not feeling secure he covers his eyes

with one hand, stretching out the {21} other to ward off the danger in

the direction in which he suspects it to lie. Nature again has

ordained that the eye of man shall close of itself, so that remaining

during his sleep without protection it shall suffer no hurt.

[Sidenote: Universal Law]

55.

Every object naturally seeks to maintain itself in itself.

56.

The part always tends to reunite with its whole in order to escape from its imperfection; the soul desires to remain with its body, because without the organic instruments of that body it can neither act nor feel.

57.

The lover is moved by the object he loves as the senses are by sensible things; and they unite and become one and the same. The work is the first thing which is born of this union; if the thing loved is base, the lover becomes base. When what is united is in harmony with that which receives it, delight, pleasure and satisfaction ensue. When the lover is united to the beloved he rests there; when the burden is laid down it finds rest there.

58.

A natural action is accomplished in the briefest manner.

{22}

59.

To such an extent does nature delight and abound in variety that among
her trees there is not one plant to be found which is exactly like
another; and not only among the plants, but among the boughs, the
leaves and the fruits, you will not find one which is exactly similar
to another.

60.

If nature had made one rule for the quality of limbs, the faces of men
would resemble each other to such a degree that it would not be
possible to distinguish one from the other; but she has varied the five
features of the face in such a way that, although she has made an
almost universal rule with regard to their size, she has not done so
with regard to their quality, so that each one can be clearly
distinguished from the other.

61.

It is an easy matter for him who knows man to arrive at universal

knowledge, since all terrestrial animals are similar in regard to their

structure, that is to say, in regard to the muscles and bones, and they

do not vary save in height and thickness; then there are the aquatic

animals, and I will not persuade the painter that any rule can be made

with regard to these because they are of infinite variety--so are the

insects.

{23}

62.

The body of anything which is fed is continually dying and being

reborn, since nourishment cannot enter save where the past nourishment

is exhausted; and if it is exhausted, it no longer has life, and if you

do not furnish it with nourishment equal to that which has been before,

you will impair the health of the organism, and if you deprive it of

this nourishment, life will be altogether destroyed. But if you supply

it with so much as can be consumed in a day, then as much life will be

restored as was consumed, like the light of the candle which is

furnished to it by the fuel provided by the moisture of the candle, and

this light with most speedy succour restores beneath what is consumed

above as it dies in dusky smoke; and this death is continuous, likewise

the continuity of the smoke is equal to the continuity of the fuel; and

in the same moment the light dies and is born again together with the

movement of its fuel.

63.

Man and animals are in reality vehicles and conduits of food, tombs of animals, hostels of Death, coverings that consume, deriving life by the death of others.

[Sidenote: Light]

64.

Look on light and consider its beauty. Shut your {24} eyes, and look again: that which you see was not there before, and that which was, no longer is. Who is he who remakes it if the producer is continually dying?

65.

Anaxagoras: Everything proceeds from everything, and everything becomes everything, because that which exists in the elements is composed of those elements.

[Sidenote: Nature]

66.

Nature appears to have been the cruel stepmother rather than the mother of many animals, and in some cases not the stepmother, but the pitying mother.

67.

Why did nature not ordain that one animal should not live by the death of the other? Nature, being inconstant and taking pleasure in continually creating and making lives and forms, because she knows that her earthly materials are thereby augmented, is more willing and swift to create than time is to destroy; and so she has ordained that many animals shall feed on each other. And as even thus her desire is not satisfied, she frequently sends forth certain poisonous and pestilential vapours upon the increasing multitude and congregation of animals, and especially upon men who increase to a great extent, because other animals do not feed on them; and since there is no cause, {25} there would follow no effect. This earth, therefore, seeks to lose its [animal] life, desiring only continual reproduction, and as, by the logical demonstration you adduce, effects often resemble their causes, animals are the image of the life of the world.

68.

Now you see that the hope and the desire of returning home to one's

former state is like the desire of the moth for the light, and the man

who, with constant yearning and joyful expectancy, awaits the new

spring and the new summer, and every new month and the new year, and

thinks that what he longs for is ever too late in coming, and does not

perceive that he is longing for his own destruction. But this desire

is the quintessence, the spirit, of the elements, which, finding itself

captive in the soul of the human body, desires always to return to its

giver. And I would have you know that this same desire is the

quintessence which is inseparable from nature, and that man is the

model of the world. And such is the supreme folly of man that he

labours so as to labour no more, and life flies from him while he

forever hopes to enjoy the goods which he has acquired at the price of

great labour.

[Sidenote: The Senses and the Soul]

69.

The soul seems to dwell in the intellect, and the intellect appears to

dwell in that part where all {26} the senses meet which is called the

brain, and the brain does not pervade the whole body, as many have

45

thought; on the contrary, it dwells entirely in one part, because if it

were all in all and the same in every part, it would not have been

necessary for the instruments of the senses to combine among themselves

in one single spot; but rather, it would have been sufficient for the

eye to fulfil the function of its sensation on the surface without

transmitting, by means of the optic nerves, the likeness of its vision

to the brain, so that the soul, for the reason given above, might

perceive it in the surface of the eye. Likewise, with regard to the

sense of hearing, it would have been sufficient if the voice had

sounded only in the porous cavity of the indurated bone which lies

within the ear, without making any further transit from this bone to

the brain, which is its destination and where it discourses with common

judgement. The sense of smell, too, is likewise compelled by necessity

to proceed to the intellect; the sense of touch passes through the

nerves and is conveyed to the brain, and these nerves diverge with

infinite ramification in the skin, which encloses the limbs of the body

and the entrails. The nerves convey volition and sensation to the

muscles, and these nerves and the tendons which lie between the muscles

and the sinews give movement to them; the muscles and sinews obey, and

this obedience takes effect by the decrease {27} of their thickness,

for in swelling their length is reduced, and the tendons which are

interwoven among the particles of the limbs shrink, and as they extend

to the tips of the fingers they transmit to the brain the cause of the

sense of touch which they feel. The tendons with their muscles obey

the nerves as soldiers obey their officers, and the nerves obey the

brain as the officers obey their captain; thus the joint of the bones

obeys the tendon, and the tendons obey the muscles, and the muscles

obey the nerves, and the nerves obey the brain, and the brain is the dwelling of the soul, and the memory is its ammunition and the perception is its refundary.

[Sidenote: Of Sensation]

70.

The brain is that which perceives what is transmitted to it by the other senses. The brain moves by means of that which is transmitted to it by the five senses. Motion is transmitted to the senses by objects, and these objects, transmitting their images to the five senses, are transferred by them to the perception, and by the perception to the brain; and there they are comprehended and committed to the memory, in which, according to their intensity, they are more or less firmly retained.

The thinkers of ancient times concluded that the part of man which constitutes his intellect is caused by an instrument to which the other five {28} senses refer everything by means of the perception, and this instrument they have named the "common sense" or brain, and they say that this sense is situated in the centre of the head. And they have given it this name "common sense" solely because it is the common judge of the five other senses, that is to say, sight, hearing, touch, taste and smell. The "common sense" is stirred by means of the perception which is placed between it and the senses. The perception is stirred

by means of the images of things conveyed to it by the external instruments to the senses, and these are placed in the centre between the external things and the perception, and the senses likewise are stirred by objects. Surrounding objects transmit their images to the senses, and the senses transfer them to the perception, and the perception transfers them to the "common sense" (brain), and by it they are stamped upon the memory, and are there retained in a greater or lesser degree according to the importance and intensity of the impression. The sense which is most closely connected with the perception is the most rapid in action, and this sense is the eye, the highest and chief of the others; of this sense alone we will treat, and we will leave the others in order not to unduly lengthen our matter.

[Sidenote: Automatic Movements]

71.

Nature has ordained for man the ministering {29} muscles which exercise the sinews, and by means of which the limbs can be moved according to the will and desire of the brain, like to officers distributed by a ruler over many provinces and towns, who represent their ruler in these places, and obey his will. And this officer, who will in a single instance have most faithfully obeyed the orders he received from his master by word of mouth, will afterwards, in a similar way, of his own accord fulfil the wishes of his master.

An example of this can be frequently seen in the fingers, which learn

to perform on an instrument the things which the intellect commands,

and the lesson once learnt they will perform it without the aid of the

intellect. And do not the muscles which cause the legs to move perform

their duty without man being conscious of it?

72.

You will see palsied and shivering persons move, and their trembling

limbs, such as their head and hands, quiver, without the permission of

the soul, and the soul, though it expend all its might, cannot prevent

these limbs from trembling. The same thing occurs in epilepsy or when

limbs are partially truncated, as in the case of tails of lizards.

[Sidenote: Intellect]

73.

It happens that our intellect is that which prompts the hand to create

the features of figures in {30} divine aspects until it finds

satisfaction; and since the intellect is one of the tones of our soul,

by means of the soul it composes the form of the body where it dwells,

according to its volition. And when it has to reproduce a human body,

it takes pleasure in repeating the body which it originally created;

whence it follows that they who fall in love are prone to become

enamoured of what resembles them.

[Sidenote: Of the Senses]

74.

There are the four powers: memory, intellect, sensuality and lust. The first two are intellectual, the others sensual. Of the five senses, sight, hearing, smell are with difficulty prevented; touch and taste not at all. Taste follows smell in the case of dogs and other greedy animals.

75.

Why does the eye perceive things more clearly in dreams than with the imagination when one is awake?

[Sidenote: Time]

76.

Although time is included among continuous quantities, being indivisible and immaterial it does not altogether fall into the scope of geometry,--by which it is divided into figures and bodies of

infinite variety, which are seen to be continuous inasmuch as they are

visible and material,--but it agrees only with its first principles,

{31} i.e. with the point and the line; the point in time may be

compared to an instant, and the line to the length of a certain

quantity of time. Just as the point is the beginning and end of a

line, so is an instant the beginning and end of any given space of

time; and just as a line is infinitely divisible, so can a given space

of time be likewise divided, and as the divisions of the line are in

proportion to each other, so likewise are the divisions of time.

77.

In twelve whole figures the cosmography of the miniature world will be

shown to you in the same manner as Ptolemy in his cosmography. And so

I will divide it afterwards into limbs as he divided the world into

provinces; then I will explain the function of the parts in every

direction, and put before your eyes a description of the whole figure

and substance of man as regards his movements by means of his limbs.

And thus if it please our great author I will demonstrate the nature of

man and his habits in the way I describe his form.

[Sidenote: On the Human Body]

78.

And thou, O man, who wilt gaze in this work of mine on the marvellous works of nature, if thou thinkest it would be an act of wickedness to destroy it, think how much more wicked it is to take the life of a man; and if this his structure appears to thee a miraculous work of art, remember that {32} it is nothing in comparison with the soul which inhabits this structure; for verily, whatever it may be, it is divine. Let it, then, dwell in His work and at His good will, and let not thy rage or malice destroy so great a thing as life, for he who does not value it does not deserve it.

[Sidenote: The Experimental Method]

79.

By these rules thou wilt be able to distinguish falsehood from truth by means of which knowledge men aim at possible things with greater moderation; and do not veil thyself in ignorance, for the result of this would be that thou wouldst be ineffectual and fall into melancholy and despair.

[Sidenote: Of Navigation below the Waters]

80.

How by the aid of a machine many may remain for some time under water.

And how and why I do not describe my method of remaining under water and of living long without food; and I do not publish nor divulge these things by reason of the evil nature of man, who would use them for assassinations at the bottom of the sea and to destroy and sink ships, together with the men on board of them; and notwithstanding I will teach other things which are not dangerous....

[Sidenote: Of Physiognomy]

81.

I will not dwell on false physiognomy and chiromancy {33} because there is no truth in them, and this is manifest because chimeras of this kind have no scientific foundation. It is true that the lineaments of the face partly reveal the character of men, their vices and temperaments; but in the face: (a) the features which separate the cheeks from the lips, and the nostrils and cavities of the eyes, are strongly marked if they belong to cheerful and good-humoured men, and if they are slightly marked it denotes that the men to whom they belong are given to meditation, (b) Those whose features stand out in great relief and depth are brutal and bad-tempered, and reason little, (c) Those who have strongly marked lines between the eyebrows are bad-tempered, (d) Those who have strongly marked lines on the forehead are men full of concealed or unconcealed bewailing.

And we can reason thus about many features. But the hand? You will

53

find that whole armies perished in the same hour by the sword in which no two men had similar marks in their hands, and the same argument applies to a shipwreck.

[Sidenote: Of Pain]

82.

Nature has placed in the front part of man, as he moves, all those parts which when struck cause him to feel pain; and this is felt in the joints of the legs, the forehead and the nose, and has been so devised for the preservation of man, because {34} if such pain were not felt in these limbs they would be destroyed by the many blows they receive.

[Sidenote: Why Plants do not feel Pain]

83.

While nature has ordained that animals should feel pain in order that the instruments which might be liable to be maimed or marred by motion may be preserved, plants do not come into collision with the objects which are before them; whence pain is not a necessity for them, and therefore when they are broken they do not feel pain, as animals do.

84.

Lust is the cause of generation.

Appetite is the support of life.

Fear or timidity is the prolongation of life.

Pain is the preserver of the instrument (of the human frame).

[Sidenote: Fear]

85.

Just as courage is the danger of life, so is fear its safeguard.

[Sidenote: Body and Soul]

86.

Let him who wishes to see how the soul inhabits its body observe what use the body makes of its daily habitation; that is to say, if the soul is full of confusion and disorder the body will be kept in disorder and confusion by the soul.

{35}

87.

The soul can never be corrupted with the corruption of the body, but it is like the wind which causes the sound of the organ, and which ceases to produce a good effect when a pipe is spoilt.

[Sidenote: Memory]

88.

Every loss which we incur leaves behind it vexation in the memory, save the greatest loss of all, that is, death, which annihilates the memory, together with life.

[Sidenote: Spirit]

89.

Our body is subject to Heaven, and Heaven is subject to the Spirit.

[Sidenote: Sense and Reason]

90.

The senses are earthly; reason lies outside them when in contemplation.

91.

Where most feeling exists, there amongst martyrs is the greatest martyr.

92.

That which can be lost cannot be deemed riches. Virtue is our true wealth and the true reward of its possessor; it cannot be lost, it never deserts us until life leaves us. Hold property and external riches with fear; they often leave their possessor scorned and mocked at for having lost them.

{36}

[Sidenote: Flight of Time]

93.

Men wrongly lament the flight of time, blaming it for being too swift; they do not perceive that its passage is sufficiently long, but a good

memory, which nature has given to us, causes things long past to seem present.

[Sidenote: Illusions]

94.

Our intellect does not judge events which happened at various intervals of time in their true proportion, because many things which happened years ago appear recent and close to the present, and often recent things appear old and seem to belong to our past childhood. The eye does likewise with regard to distant objects which in the light of the sun appear to be close to the eye, and many objects which are close appear to be remote.

95.

Let us not lack ways and means of dividing and measuring these our wretched days, which we ought to take pleasure in spending and living not vainly and not without praise, nor without leaving any memory in the minds of men, so that this our miserable existence may not be spent in vain.

[Sidenote: Virtuous Life]

96.

The age which flies glides by in stealth and deceives others; and nothing is more swift than the years, and he who sows virtue reaps glory.

{37}

[Sidenote: Sleep and Death]

97.

O sleeper, what is sleep? Sleep is like unto death. Why dost thou not work in such wise that after death thou mayst have the semblance of perfect life, just as during life thou hast in thy sleep the semblance of the hapless dead?

98.

The water you touch in a river is the last of that which has gone, and the first of that which is coming: so it is with time present.

99.

A long life is a life well spent.

[Sidenote: Life]

100.

As a well spent day affords happy sleep, so does a life profitably employed afford a happy death.

[Sidenote: Time the Destroyer]

101.

O time, consumer of things! O envious age! Thou dost destroy all things, and consumest all things with the hard teeth of old age, little by little in a slow death. Helen, when she looked in her mirror and saw the withered wrinkles made in her face by old age, wept, and wondered why she had twice been ravished. O time, devourer of things! O envious age, by which all is consumed!

{38}

[Sidenote: On Fault-finders]

102.

There exists among the foolish a certain sect of hypocrites who continually seek to deceive themselves and others, but others more than themselves, though in reality they deceive themselves more than others. And these are they who blame the painters who study on feast-days the things which relate to the true knowledge of the forms of the works of nature, and sedulously strive to acquire knowledge of these things to the best of their ability.

But such fault-finders pass over in silence the fact that this is the true manner of knowing the Artificer of such great and marvellous things, and that this is the true way in which to love so great an Inventor! For great love proceeds from the perfect knowledge of the thing loved; and if you do not know it you can love it but little or not at all; and if you love it for the gain which you anticipate obtaining from it and not for its supreme virtue, you are like the dog which wags its tail and shows signs of joy, leaping towards him who can give him a bone. But if you knew the virtue of a man you would love him more--if that virtue was in its place.

[Sidenote: Prayer]

103.

I obey Thee, Lord, first for the love which in reason I ought to bear

61

Thee; secondly because Thou {39} hast the power to shorten or prolong the lives of men.

104.

Thou, O God, dost sell us all good things at the price of labour.

105.

And many make a trade deceiving the foolish multitude, and if no one comes to unmask their deceits, they punish it.

106.

Pharisees,--that is to say, holy friars.

107.

Nothing can be written by means of new researches.

[Sidenote: Patience]

108.

Patience serves against insults as clothes do against the cold; since if you multiply your clothes as the cold increases, the cold cannot hurt you. Similarly, let thy patience increase under great offences, and they will not be able to hurt your feelings.

[Sidenote: Advice to a Speaker]

109.

Words which do not satisfy the ear of the listener will always weary or annoy him; and you will often see signs of this in such listeners in their frequent yawns. Therefore, you who speak before men whose good opinion you seek, when you {40} observe such signs of vexation, shorten your speech or vary your argument; and if you do otherwise, then instead of the favour you seek you will incur hate and hostility.

And if you would see what gives pleasure to a man speak to him on various themes, and when you see him intent, without yawning, or contracting his brow, or performing other actions, then be certain that the matter of which you are speaking is such as affords him pleasure.

[Sidenote: Advice]

110.

Here is a thing which the more it is needed the more it is rejected:
and this is advice, which is unwillingly heeded by those who most need
it, that is to say, by the ignorant.

Here is a thing which the more you fear and avoid it the nearer you
approach to it, and this is misery; the more you flee from it the more
miserable and restless you will become. When the work comes up to the
standard of the judgement, this is a bad sign for the judgement; and
when the work excels the standard of the judgement, this is the worst
sign, as occurs when a man marvels at having worked so well; and when
the standard of the judgement exceeds that fulfilled by the work, this
is a sign of perfection; and if the man is young and be thus disposed,
he will without doubt grow into an excellent workman: he will only
accomplish few works. But they will {41} be of a quality which will
compel men to contemplate their perfection with admiration.

[Sidenote: Proverbs]

111.

Nothing should be so greatly feared as empty fame.

This empty fame issues from vices.

A broken vase of clay can be remodelled, but this is no longer possible when it has been baked.

The vow is born when hope dies.

The beautiful is not always the good. And the fine talkers labour under this error without any reason.

He who wishes to grow rich in a day will be hanged in a year.

The memory of benefits is a frail defence against ingratitude.

Reprove your friend in secret and praise him in public.

He who fears dangers will not perish by them.

The evil which does me no harm is like the good which in no wise avails me.

He who offends others is not himself secure.

Be not false about the past.

Folly is the shield of lies, just as unreadiness is the defence of poverty.

Where there is liberty, there is no rule.

{42}

Here is a thing which the more it is heeded the more it is spurned,--advice.

It is ill to praise, and worse to blame, the thing which you do not understand.

On Mount Etna the words freeze in your mouth and you make ice of them.

Threats are the only weapons of the threatened man.

Ask advice of him who governs himself well.

Justice needs power, intelligence and will, and is like the Queen Bee.

Not to punish evil is equivalent to authorizing it.

He who takes the snake by the tail will be bitten by it.

The pit will fall in upon him who digs it.

He who does not restrain voluptuousness is in the category of the beasts.

You can have no dominion greater or less than that over yourself.

He who thinks little errs much.

It is easier to contend at the first than at the last.

No counsel is more sincere than that given on ships which are in danger.

Let him who acts on the advice of the young expect loss.

You grow in reputation like bread in the hands of a child.

{43}

Cannot beauty and utility be combined--as appears in citadels and men?

He who is without fear often incurs great losses, and is often full of regret.

If you governed your body according to virtue you would not live in this world.

Where good fortune enters, envy lays siege to her and attacks her, and when she departs sorrow and regret remain behind.

When beauty exists side by side with ugliness, the one seems more powerful, owing to the presence of the other.

He who walks straight rarely falls.

O miserable race of man! of how many things you make yourself the slave for the sake of money!

The worst evil which can befall the artist is that his work should appear good in his own eyes.

To speak well of a bad man is the same as speaking ill of a good man.

Truth ordains that lying tongues shall be punished by the lie.

He who does not value life does not deserve it.

The beautiful works of mortals pass and do not endure.

Labour flies with fame almost hidden in its arm.

The gold in ingots is refined in the fire.

{44}

The shuttle says: I will continue to move until the cloth is woven.

Everything that is crooked is straightened.

Great ruin proceeds from a slight cause.

68

Fine gold is recognized when it is tested.

The image will correspond to the die.

The wall will fall on him who scrapes it.

Ivy lives long.

To the traitor, death is life, because if he makes use of others he is no longer believed.

When fortune comes seize her in front firmly, because behind she is bald.

Constancy means, not he who begins, but he who perseveres.

I do not yield to obstacles.

Every obstacle is overcome by resolve.

He who is chained to a star does not change.

[Sidenote: Truth]

112.

Fire destroys falsehood,--that is to say, sophistry,--and rehabilitates truth, scattering the darkness.

Fire must be represented as the consumer of all sophistry and the revealer of truth, because it is light and scatters darkness which conceals all essences.

Fire destroys all sophistry,--that is to say, deceit,--and preserves truth alone, which is gold. {45} Truth cannot be concealed in the end, dissimulation is of no avail. Dissimulation is frustrated before so great a judge. Falsehood puts on a mask.

There is nothing hidden under the sun. Fire must represent truth because it destroys all sophistry and lies, and the mask is for sophistry and lies, which conceal truth.

113.

Rather privation of limbs than weariness of doing good. The power of using my limbs shall fail me before the power of being useful. Rather death than weariness. I cannot be satiated with serving. I do not weary of giving help. No amount of work is sufficient to weary me. This is a carnival motto: "Sine lassitudine." Hands in which ducats and precious stones abound like snow never grow weary of serving, but such a service is for its utility only and not for our profit. Nature

has formed me thus.

[Sidenote: Ingratitude]

114.

This shall be placed in the hand of ingratitude: The wood nourishes the

fire that consumes it. When the sun, the scatterer of darkness,

shines, you put out the light which for you in particular, and for your

need and convenience, expelled the darkness.

[Sidenote: Physiological Inferiority of Man]

115.

I have found that in the composition of the human body as compared with

the bodies of {46} animals the senses are less subtle and coarser; it

is thus composed of less ingenious machinery and of cells less capable

of receiving the power of senses. I have seen that in the lion the

sense of smell is connected with the substance of the brain and

descends through the nostrils which form an ample receptacle for it;

and it enters into a great number of cartilaginous cells which are

provided with many passages in order to receive the brain. A large

part of the head of the lion is given up to the sockets of the eyes,

and the optic nerves are in immediate contact with the brain; the

contrary occurs in man, because the sockets of the eyes occupy a small

portion of the head, and the optic nerves are subtle and long and weak,

and owing to the weakness of their action we see little by day and less

at night; and the animals above mentioned see better at night than in

the daytime; and the proof of this is that they seek their prey at

night and sleep during the daytime, as do also the nocturnal birds.

[Sidenote: Man's Ethical Inferiority]

116.

Thou hast described him king of animals, but I would rather say, king

of beasts, thou being the greatest--for hast thou not slain them in

order that they may give thee their children to glut thy greed with

which thou hast striven to make a sepulchre for all animals? And I

would say still more if I might speak the whole truth. But let us {47}

confine ourselves to human matters, relating one supreme infamy, which

is not to be found among the animals of the earth; because among these

you will not find animals who eat their young, except when they are

utterly foolish (and there are few indeed of such among them), and this

occurs only among the beasts of prey, such as the lions, and leopards,

panthers, lynxes, cats and the like, which sometimes feed on their

young; but thou, besides thy children, dost devour thy father, thy

mother, thy brother and thy friends; and not satisfied with this, thou

goest forth to hunt on the islands of others, seizing other men and

these half naked ... thou fattenest and chasest them down thy own

throat. Now does not nature produce enough vegetables for thee to satisfy thyself? And if thou art not content with vegetables, canst thou not by a mixture of them make infinite compounds as Platina wrote, and other writers on food?

[Sidenote: Man in the Animal World]

117.

The description of man, including that of such creatures belonging almost to the same species, such as apes, monkeys and the like, of which there are many.

118.

The way of walking in man is similar in all cases to the universal way of walking in four-footed animals, because, just as they move their feet {48} crosswise, like a trotting horse, so man moves his four limbs crosswise, that is to say, in walking he puts forward his right foot simultaneously with his left arm, and so on vice versa.

119.

Write a special treatise to describe the movements of four-footed

animals, among which is man, who in his childhood also walks on four feet.

[Sidenote: Fragment of a Letter]

120.

There is one who having promised me much less than his due, and being disappointed of his presumptuous desire, has tried to deprive me of all my friends; and finding them wise and not pliable to his will, he has threatened me that he would bring accusations against me and alienate my benefactors from me: hence I have informed Your Lordship of this, so that this man, who wishes to sow the usual scandals, may not find a soil fit for sowing the thoughts and deeds of his evil nature; and that when he tries to make Your Lordship the tool of his infamous and malicious nature he may be disappointed of his desire.

[Sidenote: Giacomo of Pupil of Leonardo]

121.

On the 23d of April, 1490, I began this book; and started again on the horse. Giacomo came to live with me on Saint Mary Magdalen's day in 1490; {49} he was ten years old. He was a thief, a liar, obstinate, and a glutton. On the second day I had two shirts made for him, a pair

74

of socks and a jerkin, and when I placed the money aside to pay for these things, he stole it out of the purse and I could never force him to confess the fact, though I was quite certain of it--4 lire. On the following day I went to sup with Giacomo Andrea, and this same Giacomo supped for two and did mischief for four, since he broke three bottles, spilled the wine, and after this came to sup where I... Item: on the 7th of September he stole a silver point, worth twelve soldi, from Marco, who was living with me, and took it from his studio; and when Marco had looked for it for some time he found it hidden in Giacomo's box--lire 1, soldi 2. Item: on the 26th of the following January, being in the house of Messer Galeazzo di San Severino, in order to arrange the festivity of his joust, and certain henchmen having undressed to try on the costumes of rustics who were to take part in the aforesaid festivity, Giacomo took the purse of one of them, which was on the bed with other clothes, and stole the money he found in it--2 lire, 4 soldi. Item: Maestro Agostino of Padua gave me while I was in the same house a Turkish hide to have a pair of shoes made of it, and Giacomo stole this from me within a month and sold it to a cobbler for 20 soldi, with which money by his own confession he bought sweets of aniseed. Item: {50} again, on the 2d of April, Giovanni Antonio left a silver point on one of his drawings, and Giacomo stole it; it was worth 24 soldi,--1 lire, 4 soldi. The first year a cloak, 2 lire; six shirts, 4 lire; three doublets, 6 lire: four pairs of socks, 7 lire, 8 soldi.

122.

And in this case I know that I shall make not a few enemies, since no one will believe what I say of him; because there are but few whom his vices have disgusted, indeed they only disgusted those men whose natures are contrary to such vices; and many hate their fathers and break off friendship with those who reprove their vices, and they will have no examples brought up against them, nor tolerate any advice. And if you meet with any one who is good and virtuous drive him not away from you, do him honour, so that he may not have to flee from you and hide in hermitages, or caverns and other solitary spots, in order to escape from your treachery; and if there be such an one do him honour, because these are your gods upon earth, they deserve statues from you and images ... but remember that you are not to eat their images, as is practised still in some parts of India, where, when images have performed some miracle, the priests cut them in pieces (since they are of wood) and distribute them among the people of the country, not {51} without payment, and each one grates his portion very fine and puts it upon the first food he eats; and thus they believe that they have eaten their saint by faith, who will preserve them from all perils. What is thy opinion, O man, of thy own species? Art thou so wise as thou believest to be? Are these things to be done by men?

[Sidenote: Pleasure and Pain]

123.

This represents pleasure together with pain because one is never separated from the other; they are depicted back to back because they are opposed to each other; they are represented in one body because they have the same basis, because the source of pleasure is labour mingled with pain, and the pain issues from the various evil pleasures. And it is therefore represented with a reed in its right hand which is ineffectual and devoid of strength, and the wounds inflicted by it are poisonous. In Tuscany such reeds are placed to support beds, to signify that this is the place of idle dreams, that here a great part of life is consumed, here much useful time is wasted, that is, the morning hours when the mind is sober and rested and the body disposed to start on fresh labours; there, again, many vain pleasures are enjoyed by the mind, which pictures to itself impossible things, and by the body, which indulges in those pleasures that are so often the cause of the {52} failing of life; and for this reason the reed is used as their support.

[Sidenote: Brain and Soul]

124.

The spirit returns to the brain whence it had departed, with a loud voice and uttering these words:

O blissful and fortunate spirit, whence comest thou? I have known this man well, against my will. He is a receptacle of villainy, he is a

77

very heap of the highest ingratitude combined with all the other vices. But why should I tire myself with vain words? Nothing is to be found in him save the accumulation of all sins, and if there is to be found among them any that possess good, they will not be treated differently than I have been by other men; in short I have come to the conclusion that they are bad if they are enemies, and worse if they are friends.

[Sidenote: Of the Eye]

125.

The eye, which reflects the beauty of the universe to those who see, is so excellent a thing that he who consents to its loss deprives himself of the spectacle of the works of nature; and it is owing to this spectacle, effected by means of the eye, which enables the soul to behold the various objects of nature, that the soul is content to remain in the prison of the body; but he who loses his eyesight leaves the soul in a dark prison, where {53} all hope of once more beholding the sun, the light of the whole world, is lost.... And how many are they who feel great hatred for the darkness of night, although it is brief. Oh! what would they do were they constrained to abide in this darkness during the whole of their life? Certainly there is no one who would not rather lose his hearing or his sense of smell than his eyesight, and the loss of hearing includes the loss of all sciences which find expression in words; and this loss a man would incur solely so as not to be deprived of the sight of the beauty of the world which

78

consists in the surfaces of bodies artificial as well as natural, which

are reflected in the human eye.

[Sidenote: The Eye in Animal Life]

126.

Animals suffer greater loss in losing their sight than their hearing

for many reasons: firstly, because it is by means of their sight that

they find the food which is their nourishment, and is necessary for all

animals; secondly, because by means of sight the beauty of created

things is apprehended, especially those which lead to love, while he

who is born blind cannot apprehend such beauty by hearing, because he

has never received any knowledge as to what is beauty of any kind.

There remains hearing, by which I mean only the human voice and speech;

they contain the names of all things whatsoever. It is possible to

live happily without the knowledge of these {54} words, as is seen in

those who are born deaf, that is to say, the dumb, who take delight in

drawing.

[Sidenote: Ascension of Monte Rosa]

127.

I say that the azure we see in the atmosphere is not its true colour,

79

but is caused by warm moisture evaporated in minute and insensible

atoms which the solar rays strike, rendering them luminous against the

darkness of the infinite night of the fiery region which lies beyond

and includes them. And this may be seen, as I saw it, by him who

ascends Mounboso (Monte Rosa), a peak of the Alps which separates

France from Italy. The base of this mountain gives birth to the four

large rivers which in four different directions water the whole of

Europe; and no mountain has its base at so great a height as this. It

rises to such a height that it almost lifts itself up above the clouds;

snow seldom falls on it, but only hail in summer, when the clouds are

at their greatest height, and this hail is preserved there so that were

it not for the absorption of the rising and falling clouds, which does

not occur twice in an age, a great quantity of ice would be piled up

there by the hail, which in the middle of July I found to be very

considerable; and I saw above me the dark air, and the sun which struck

the mountain shone far lighter than in the plains below, because a

lesser quantity of atmosphere lay between the summit of the mountain

and the sun.

{55}

[Sidenote: Prophecies]

128.

Men will communicate with each other from the most distant countries,
and reply.

Many will abandon their own habitations and take with them their own goods, and go and inhabit other countries.

Men will pursue the thing which they most greatly fear; that is to say, they will be miserable in order to avoid falling into misery.

Men standing in separate hemispheres will converse with each other, embrace each other, and understand each other's language.

129.

We should not desire the impossible.

{59}

II

THOUGHTS ON ART

* *

*

The painter's work will be of little merit if he takes the painting of others as his standard, but if he studies from nature he will produce good fruits; as is seen in the case of the painters of the age after the Romans, who continued to imitate one another and whose art consequently declined from age to age. After these came Giotto the Florentine, who was born in the lonely mountains, inhabited only by goats and similar animals; and he, being drawn to his art by nature, began to draw on the rocks the doings of the goats of which he was the keeper; and thus he likewise began to draw all the animals which he met with in the country: so that after long study he surpassed not only all the masters of his age, but all those of many past centuries. After him art relapsed once more, because all artists imitated the painted pictures, and thus from century to century it went on declining, until Tomaso the Florentine, called Masaccio, proved by his perfect work that they who set up for themselves a standard other than nature, the mistress of all masters, labour in vain.

{60}

Thus I wish to say, in regard to these mathematical matters, that they who merely study the masters and not the works of nature are the grandchildren, and not the children, of nature, the mistress of good masters. I abhor the supreme folly of those who blame the disciples of nature in defiance of those masters who were themselves her pupils.

82

2.

The first picture was a single line, drawn round the shadow of a man cast by the sun on the wall.

3.

Vastness of the field of painting: All that is visible is included in the science of painting.

4.

With due lamentation Painting complains that it has been expelled from the liberal arts, because it is the true daughter of nature and is practised by means of the most worthy of the senses. Whence wrongly, O writers, you have excluded painting from the liberal arts, since it not only includes in its range the works of nature, but also infinite things which nature never created.

5.

Because writers have had no knowledge of the science of painting, they have not been able to {61} describe its gradations and parts, and since painting itself does not reveal itself nor its artistic work in words, it has remained, owing to ignorance, behind the sciences mentioned above, but it has thereby lost nothing of its divinity. And truly it is not without reason that men have failed to honour it, because it does honour to itself without the aid of the speech of others, just as do the excellent works of nature. And if the painters have not described the art of painting, and reduced it to a science, the fault must not be imputed to painting and it is no less noble on that account, since few painters profess a knowledge of letters, as their life would not be long enough for them to acquire such knowledge. Therefore we ask, Is the virtue of herbs, stones and plants non-existent because men have been ignorant of it? Certainly not; but we will say that these herbs remained noble in themselves without the aid of human tongues or letters.

[Sidenote: Painting]

6.

A science is more useful in proportion as its fruits are more widely understood, and thus, on the other hand, it is less useful in proportion as it is less widely understood. The fruits of painting can

84

be apprehended by all the populations of the universe because its results are subject to the power of sight, and it does not pass by the ear to the brain, but by the same channel by which {62} sight passes. Therefore it needs no interpreters of diverse tongues, as letters do, and it has instantly satisfied the human race in the same manner as the works of nature have done. And not only the human race, but other animals; as was shown in a picture representing the father of a family to whom little children still in the cradle gave caresses, as did the dog and the cat in the same house; and it was a wonderful thing to see such a sight.

7.

The arts which admit of exact reproduction are such that the disciple is on the same level as the creator, and so it is with their fruits. These are useful to the imitator, but are not of such high excellence as those which cannot be transmitted as an inheritance like other substances. Among these painting is the first. Painting cannot be taught to him on whom nature has not conferred the gift of receiving such knowledge, as mathematics can be taught, of which the disciple receives as much as the master gives him; it cannot be copied, as letters can be, in which the copy equals the original; it cannot be stamped, in the same way as sculpture, in which the impression is in proportion to the source as regards the quality of the work; it does not generate countless children, as do printed books. It alone remains noble, it alone confers honour on its author and remains precious {63}

and unique, and does not beget children equal to itself. And it is
more excellent by reason of this quality than by reason of those which
are everywhere proclaimed. Now do we not see the great monarchs of the
East going about veiled and covered up from the fear of diminishing
their glory by the manifestation and the divulgation of their presence?
and do we not see that the pictures which represent the divine deity
are kept covered up with inestimable veils? their unveiling is preceded
by great sacred solemnities with various chants and diverse music, and
when they are unveiled, the vast multitude of people who are there
flocked together, immediately prostrate themselves and worship and
invoke those whom such pictures represent that they may regain their
lost holiness and win eternal salvation, just as if the deity were
present in the flesh. This does not occur in any other art or work of
man. And if you say that is owing to the nature of the subject
depicted rather than to the genius of the painter, the answer is that
the mind of man could satisfy itself equally well in this case, were
the man to remain in bed and not make pilgrimages to places which are
perilous and hard of access, as we so often see is the case. But if
such pilgrimages continually exist, what is then their unnecessary
cause? You will certainly admit that it is an image of this kind, and
all the writings in the world could not succeed in representing the
{64} semblance and the power of such a deity. Therefore it appears
that this deity takes pleasure in the pictures and is pleased that it
should be loved and revered, and takes a greater delight in being
worshipped in that rather than in any other semblance of itself, and by
reason of this it bestows grace and gifts of salvation according to the
belief of those who meet together in such a place.

8.

The eye, which is called the window of the soul, is the principal means by which the brain can most abundantly and splendidly contemplate the infinite works of nature; and the ear is the next in order, which is ennobled by hearing the recital of the things seen by the eye. If you, historians and poets, or mathematicians, had not seen things with the eyes, you could not report of them in writing. If thou, O poet, dost tell a story with thy painting pen, the painter will more easily give satisfaction in telling it with his brush and in a manner less tedious and more easily understood. And if thou callest painting mute poetry, the painter can call poetry blind painting. Now consider which is the greater loss, to be blind or dumb? Though the poet is as free as the painter in his creations and compositions, they are not so satisfactory to men as paintings, because if poetry is able to describe forms, actions and places in words, the painter deals with the very {65} semblance of forms in order to represent them. Now consider which is nearer to man, the name of man or the image of man? The name of man varies in diverse countries, but death alone changes his form. If thou wast to say that painting is more lasting, I answer that the works of a coppersmith, which time preserves longer than thine or ours, are more eternal still. Nevertheless there is but little invention in it, and painting on copper with colours of enamel is far more lasting.

We by our art can be called the grandsons of God. If poetry deals with

moral philosophy, painting deals with natural philosophy; if poetry

describes the action of the contemplative mind, painting represents the

effect in motion of the action of the mind; if poetry terrifies people

with the pictures of Hell, painting does the same by depicting the same

things in action. If a poet challenges the painter to represent

beauty, fierceness, or an evil, an ugly or a monstrous thing, whatever

variety of forms he may produce in his way, the painter will cause

greater satisfaction. Are there not pictures to be seen so like

reality that they deceive men and animals?

[Sidenote: Painting creates Reality]

9.

The imagination is to the effect as the shadow to the opaque body which

causes the shadow, and the proportion is the same between poetry and

painting. Because poetry produces its results in the {66} imagination

of the reader, and painting produces them in a concrete reality outside

the eye, so that the eye receives its images just as if they were the

works of nature; and poetry produces its results without images, and

they do not pass to the brain through the channel of the visual

faculty, as in painting.

10.

Painting represents to the brain the works of nature with greater truth
and accuracy than speech or writing, but letters represent words with
greater truth, which painting does not do. But we say that the science
which represents the works of nature is more wonderful than that which
represents the works of the artificer, that is to say, the works of
man, which consist of words--such as poetry and the like--which issue
from the tongue of man.

[Sidenote: The Painter goes to Nature]

11.

Painting ministers to a nobler sense than poetry, depicts the forms of
the works of nature with greater truth than poetry; and the works of
nature are nobler than the words which are the works of man, because
there is the same proportion between the works of man and those of
nature as there is between man and God. Therefore it is a more worthy
thing to imitate the works of nature, which are the true images
embodied in reality, than to imitate the actions and the words of men.

{67}

And if thou, O poet, wishest to describe the works of nature by thine
unaided art, and dost represent various places and the forms of diverse

89

objects, the painter surpasses thee by an infinite degree of power; but
if thou wishest to have recourse to the aid of other sciences, apart
from poetry, they are not thy own; for instance, astrology, rhetoric,
theology, philosophy, geometry, arithmetic and the like. Thou art not
then a poet any longer. Thou transformest thyself, and art no longer
that of which we are speaking. Now seest thou not that if thou wishest
to go to nature, thou reachest her by the means of science, deduced by
others from the effects of nature? And the painter, through himself
alone, without the aid of aught appertaining to the various sciences,
or by any other means, achieves directly the imitation of the things of
nature. By painting, lovers are attracted to the images of the beloved
to converse with the depicted semblance. By painting whole populations
are led with fervent vows to seek the image of the deities, and not to
see the books of poets which represent the same deities in speech; by
painting animals are deceived. I once saw a picture which deceived a
dog by the image of its master, which the dog greeted with great joy;
and likewise I have seen dogs bark at and try to bite painted dogs; and
a monkey make a number of antics in front of a painted monkey. I have
seen swallows fly and alight on painted {68} iron-works which jut out
of the windows of buildings.

[Sidenote: Superiority of Painting to Philosophy]

12.

Painting includes in its range the surface, colour and shape of

anything created by nature; and philosophy penetrates into the same

bodies and takes note of their essential virtue, but it is not

satisfied with that truth, as is the painter, who seizes hold of the

primary truth of such bodies because the eye is less prone to deception.

[Sidenote: Painting & Poetry]

13.

Poetry surpasses painting in the representation of words, and in the

representation of actions painting excels poetry; and painting is to

poetry as actions are to words, because actions depend on the eye and

words on the ear; and thus the senses are in the same proportion one to

another as the objects on which they depend; and on this account I

consider painting to be superior to poetry. But since those who

practised painting were for long ignorant as to how to explain its

theory, it lacked advocates for a considerable time; because it does

not speak itself, but reveals itself and ends in action, and poetry

ends in words, which in its vainglory it employs for self-praise.

[Sidenote: Painting is Mute Poetry]

14.

What poet will place before thee in words, O {69} lover, the true

semblance of thy idea with such truth as will the painter? Who is he

who will show thee rivers, woods, valleys and plains, which will recall

to thee the pleasures of the past, with greater truth than the painter?

And if thou sayest that painting is mute poetry in itself, unless there

be some one to speak for it and tell what it represents--seest thou

not, then, that thy book is on a lower plane? Because even if it have

a man to speak for it, nothing of the subject which is related can be

seen, as it is seen when a picture is explained. And the pictures, if

the action represented and the mental attributes of the figures are in

the true proportion one to another, will be understood in the same way

as if they spoke.

15.

Painting is mute poetry, and poetry is blind painting. Therefore these

two forms of poetry, or rather these two forms of painting, have

exchanged the senses through which they should reach the intellect.

Because if they are both of them painting, they must reach the brain by

the noblest sense, namely, the eye; if they are both of them poetry,

they must reach the brain by the less noble sense, that is, the

hearing. Therefore we will appoint the man born deaf to be judge of

painting, and the man born blind to be judge of poetry; and if in the

painting the movements are appropriate {70} to the mental attributes of

the figures which is are engaged in any kind of action, there is no

doubt that the deaf man will understand the action and intentions of

the figures, but the blind man will never understand what the poet

shows, and what constitutes the glory of the poetry; since one of the noblest functions of its art is to describe the deeds and the subjects of stories, and adorned and delectable places with transparent waters in which the green recesses of their course can be seen as the waves disport themselves over meadows and fine pebbles, and the plants which are mingled with them, and the gliding fishes, and similar descriptions, which might just as well be made to a stone as to a man born blind, since he has never seen that which composes the beauty of the world, that is, light, darkness, colour, body, shape, place, distance, propinquity, motion and rest, which are the ten ornaments of nature.

But the deaf man, lacking the less noble sense, although he has at the same time lost the gift of speech, since never having heard words spoken he never has been able to learn any language, will nevertheless perfectly understand every attribute of the human body better than a man who can speak and hear; and likewise he will know the works of painters and what is represented in them, and the action which is appropriate to such figures.

{71}

[Sidenote: Painting is Mute Poetry]

16.

Painting is mute poetry, and poetry is blind painting, and both imitate

93

nature to the best of their powers, and both can demonstrate moral principles, as Apelles did in his Calumny. And since painting ministers to the most noble of the senses, the eye, a harmonious proportion ensues from it, that is to say, that just as from the concord of many diverse voices at the same moment there ensues a well-proportioned harmony which will please the sense of hearing to such an extent that the listeners in dizzy admiration are like men half ravished of their senses, still greater will be the effect of the beautiful proportions of a celestial face in a picture from whose proportions a harmonious concord will ensue, which delights the eye in one moment, just as music delights the ear. And if this harmonious beauty is shown to one who is the lover of the woman from whom such great beauty has been copied, he will most certainly be struck dizzy with admiration and incomparable joy superior to that afforded by all the other senses.

But with regard to poetry, which in order to afford the representation of a perfect beauty is obliged to describe each separate part in detail,--a representation which in painting produces the harmony described above,--no further charm is produced than would occur in music if each voice {72} were to be heard separately at various intervals of time, whence no concord would ensue; just as if we wished to show a countenance bit by bit, always covering up the parts already shown, forgetfulness would prevent the production of any harmonious concord, since the eye could not apprehend the parts with its visual faculty at the same moment. The same thing occurs in the beauty of any object created by the poet, for as its parts are related separately, at

separate times the memory receives no harmony from it.

[Sidenote: The Impression of Painting]

17.

Painting reveals itself immediately to thee with the semblance given it by its creator, and affords to the chief of the senses as great a delight as any object created by nature. And the poet in this case reveals the same objects to the brain by the channel of the hearing, the inferior sense, and affords the eye no more pleasure than it derives from anything which is related. Now consider what a difference there is between hearing the recital of a thing which in the course of time gives pleasure to the eye, and perceiving it with the same velocity with which we apprehend the works of nature.

And in addition to the fact that a long interval of time is necessary to read the works of the poets, it often occurs that they are not understood, and it is necessary to make diverse {73} comments on them, and it is exceedingly rare that the commentators are agreed as to the meaning of the poet; and often the readers peruse but a small portion of their works, owing to lack of time. But the works of the painter are immediately understood by those who behold them.

18.

Painting manifests its essence to thee in an instant of time,--its

essence by the visual faculty, the very means by which the perception

apprehends natural objects, and in the same duration of time,--and in

this space of time the sense-satisfying harmony of the proportion of

the parts composing the whole is formed. And poetry apprehends the

same things, but by a sense inferior to that of the eyesight, which

bears the images of the objects named to the perception with greater

confusion and less speed. Not in such wise acts the eye (the true

intermediary between the object and the perception), for it immediately

communicates the true semblance and image of what is represented before

it with the greatest accuracy; whence that proportion arises called

harmony, which with sweet concord delights the sense in the same way as

the harmony of diverse voices delights the ear; and this harmony is

less worthy than that which delights the eye, because for every part of

it that is born a part dies, and it dies as fast as it is born. This

{74} cannot occur in the case of the eye; because if thou presentest a

beautiful living mortal to the eye, composed of a harmony of fair

limbs, its beauty is not so transient nor so quickly destroyed as that

of music; on the contrary it has permanent duration, and allows thee to

behold and consider it; and it is not reborn as in the case of music

which is played many times over, nor will it weary thee: on the

contrary, thou becomest enamoured with it, and the result it produces

is that all the senses, together with the eye, would wish to possess

it, and it seems that they would wish to compete with the eye: it

appears that the mouth desires it for itself, if the mouth can be

considered as a sense; the ear takes pleasure in hearing its beauty;

the sense of touch would like to penetrate into all its pores; the nose also would like to receive the air it exhales.

Time in a few years destroys this harmony, but this does not occur in the case of beauty depicted by the painter, because time preserves it for long; and the eye, as far as its function is concerned, receives as much pleasure from the depicted as from the living beauty; touch alone is lacking to the painted beauty,--touch, which is the elder brother of sight; which after it has attained its purpose does not prevent the reason from considering the divine beauty. And in this case the picture copied from the living beauty acts for the greater part as a substitute; and the {75} description of the poet cannot accomplish this.--the poet who is now set up as a rival to the painter, but does not perceive that time sets a division between the words in which he describes the various parts of the beauty, and that forgetfulness intervenes and divides the proportions which he cannot name without great prolixity; he cannot compose the harmonious concord which is formed of divine proportions. And on this account beauty cannot be described in the same space of time in which a painted beauty can be seen, and it is a sin against nature to attempt to transmit by the ear that which should be transmitted by the eye.

What prompts thee, O man, to abandon thy habitations in the city, to leave thy parents and friends, and to seek rural spots in the mountains and valleys, if it be not the natural beauty of the world, which, if thou reflectest, thou dost enjoy solely by means of the sense of sight? And if the poet wishes to be called a painter in this connection also,

why didst thou not take the descriptions of places made by the poet and remain at home without exposing thyself to the heat of the sun? Oh! would not this have been more profitable and less fatiguing to thee, since this can be done in the cool without motion and danger of illness? But the soul could not enjoy the benefit of the eyes, the windows of its dwelling, and it could not note the character of joyous {76} places; it could not see the shady valleys watered by the sportiveness of the winding rivers; it could not see the various flowers, which with their colours make a harmony for the eye, and all the other objects which the eye can apprehend. But if the painter in the cold and rigorous season of winter can evoke for thee the landscapes, variegated and otherwise, in which thou didst experience thy happiness; if near some fountain thou canst see thyself, a lover with thy beloved, in the flowery fields, under the soft shadow of the budding boughs, wilt thou not experience a greater pleasure than in hearing the same effect described by the poet?

Here the poet answers, admitting these arguments; but he maintains that he surpasses the painter, because he causes men to speak and reason in diverse fictions, in which he invents things which do not exist, and that he will incite men to take arms, and describe the heavens, the stars, nature, and the arts and everything.

To which we reply that none of these things of which he speaks is his true profession; but if he wishes to speak and make orations, it can be shown that he is surpassed by the orator in this province; and if he speaks of astrology, that he has stolen the subject of the astrologer;

98

and in the case of philosophy, of the philosopher; and that in reality poetry has no true position and merits no more consideration than a shopkeeper {77} who collects goods made by various workmen. As soon as the poet ceases to represent by means of words the phenomena of nature, he then ceases to act as a painter, because if the poet leaves such representation and describes the flowery and persuasive speech of him to whom he wishes to give speech, he then becomes an orator, and neither a poet nor a painter; and if he speaks of the heavens he becomes an astrologer, and a philosopher and a theologian if he discourses of nature or God; but if he returns to the description of any object he would rival the painter, if with words he could satisfy the eye as the painter does.

But the spirit of the science of painting deals with all works, human as well as divine, which are terminated by their surfaces, that is, the lines of the limits of bodies by means of which the sculptor is required to achieve perfection in his art. She with her fundamental rules, i.e. drawing, teaches the architect how to work so that his building may be pleasant to the eye; she teaches the makers of diverse vases, the goldsmiths, weavers, embroiderers; she has found the characters with which diverse languages find expression; she has given symbols to the mathematicians; she has taught geometry its figures, and instructed the astrologers, the makers of machines and engineers.

[Sidenote: Poet and Painter]

19.

The poet says that his science consists of {78} invention and rhythm, and this is the simple body of poetry, invention as regards the subject matter and rhythm as regards the verse, which he afterwards clothes with all the sciences. To which the painter rejoins that he is governed by the same necessities in the science of painting, that is to say, invention and measure (fancy as regards the subject matter which he must invent, and measure as regards the matters painted), so that they may be in proportion, but that he does not make use of three sciences; on the contrary it is rather the other sciences that make use of painting, as, for instance, astrology, which effects nothing without the aid of perspective, the principal link of painting,--that is, mathematical astronomy and not fallacious astrology (let those who by reason of the existence of fools make a profession of it, forgive me). The poet says he describes an object, that he represents another full of beautiful allegory; the painter says he is capable of doing the same, and in this respect he is also a poet. And if the poet says he can incite men to love, which is the most important fact among every kind of animal, the painter can do the same, all the more so because he presents the lover with the image of his beloved; and the lover often does with it what he would not do with the writer's delineation of the same charms, i.e. talk with it and kiss it; so great is the painter's influence on the minds of men that he incites them to love and {79} become enamoured of a picture which does not represent any living woman.

And if the poet pleases the sense by means of the ear, the painter does

so by the eye, which is the superior sense. I will enlarge no further on this theme save to say that if a good painter were to represent the fury of a battle, and if the poet were to describe one, and both representations were put before the public together, you will see before which of the two most of the spectators will stop, to which of the two they will pay most attention, which of the two will be the most praised and give the greater satisfaction. Without any doubt, the painting, being infinitely the most beautiful and useful, will please the most. Write the name of God in some spot, and set up His image opposite, and you will see which will be the most reverenced. While painting embraces in itself all the forms of nature, you have nothing save words, which are not universal, like forms. If you have the effects of the representation, we have the representation of the effects. Take a poet who describes the charms of a woman to her lover, and a painter who represents her, and you will see whither nature leads the enamoured critic. Certainly the proof should rest on the verdict of experience. You have classed painting among the mechanical arts, but, truly, if painters were as apt at praising their own works in writing as you are, it would not lie under the stigma {80} of so unhonoured an name. If you call it mechanical because it is by manual work and that the hand represents the conception of the imagination, you writers put down with the pen the conceptions of your mind. And if you say that it is mechanical because it is done for money, who is more guilty of this error--if error it can be called--than you? If you lecture in the schools, do you not go to whomsoever rewards you most? Do you perform any work without some pay? Although I do not say this to blame such opinions, because all labour expects its reward; and if a

poet were to say: "I will devise with my fancy a work which shall be pregnant with meaning," the painter can do the same, as Apelles did when he painted The Calumny.

[Sidenote: King Matthias & the Poet]

20.

On the birthday of King Matthias, a poet brought him a work made in praise of the royal birthday for the benefit of the world, and a painter presented him with a portrait of his lady-love. The king immediately shut the book of the poet and turned to the picture, and remained gazing on it with profound admiration. Then the poet, greatly slighted, said: "O king, read, read, and thou wilt hear something of far greater substance than a dumb picture!" Then the king, hearing himself blamed for contemplating a mute object, said: "O poet, be silent, thou knowest not what thou {81} sayest; this picture gratifies a nobler sense than thy work, which is for the blind. Give me an object which I can see and touch and not only hear, and blame not my choice in having placed thy work beneath my elbow, while I hold the work of the painter with both my hands before my eyes, because my very hands have chosen to serve a worthier sense than that of hearing.

"And as for my self I consider that the same proportion exists between the art of the painter and that of the poet as that which exists between the two senses on which they respectively depend.

102

"Knowest thou not that our soul is composed of harmony, and harmony can only be begotten in the moments when the proportions of objects are simultaneously visible and audible? Seest thou not that in thine art there is no harmony created in a moment, and that, on the contrary, each part follows from the other in succession, and the second is not born before its predecessor dies. For this reason I consider thy creation to be considerably inferior to that of the painter, simply because no harmonious concord ensues from it. It does not satisfy the mind of the spectator or the listener, as the harmony of the perfect features which compose the divine beauty of this face which is before me; for the features united all together simultaneously afford me a pleasure which I consider to be unsurpassed by any other thing on the earth which is made by man."

{82}

[Sidenote: Value of the Visible Universe]

21.

There is no one so foolish who if offered the choice between everlasting blindness and deafness would not immediately elect to lose both his hearing and sense of smell rather than to be blind. Since he who loves his sight is deprived of the beauty of the world and all created things, and the deaf man loves only the sound made by the percussion of the air, which is an insignificant thing in the world.

Thou sayest that science increases in nobility in proportion as the subjects with which it deals are more elevated, and, for this reason, a false rendering of the being of God is better than the portrayal of a less worthy object; and on this account we will say that painting, which deals alone with the works of God, is worth more than poetry, which deals solely with the lying imaginings of human devices.

[Sidenote: Poet and Painter]

22.

Thou sayest, O painter, that worship is paid to thy work, but impute not this power to thyself, but to the subject which such a picture represents. Here the painter makes answer: O thou poet, who sayest that thou also art an imitator, why dost thou not represent with thy words objects of such a nature that thy writings which contain these words may be worshipped also? But nature has favoured the painter more than the poet, {83} and it is fair that the works of the more greatly favoured one should be more honoured than those of the less favoured one. Therefore let us praise him who with words satisfies the hearing, and him who by painting affords perfect content to the eyes; but let the praise given to the worker in words be less, inasmuch as they are accidental and created by a less worthy author than the works of nature of which the painter is the imitator. And the existence of these works is confined within the forms of their surfaces.

23.

Since we have concluded that the utmost extent of the comprehension of poetry is for the blind, and that of painting for the deaf, we will say that the value of painting exceeds that of poetry in proportion as painting gratifies a nobler sense than poetry does, and this nobility has been proved to be equal to that of three other senses, because we elect to lose our sense of hearing, smell and touch rather than our eyesight. For he who loses his sight is deprived of the beauty of the universe, and is like to one who is confined during his lifetime in a tomb, in which he enjoys life and motion.

Now seest thou not that the eye comprehends the beauty of the whole world? It is the head of astrology; it creates cosmography; it gives counsel and correction to all the human arts; it impels {84} men to seek diverse parts of the world; it is the principle of mathematics; its science is most certain; it has measured the height and the magnitude of the stars; it has discovered the elements and their abodes; it has been able to predict the events of the future, owing to the course of the stars; it has begotten architecture and perspective and divine painting. O most excellent above all the things created by God! What praise is there which can express thy nobility? What peoples, what tongues, are they who can perfectly describe thy true working? It is the window of the human body, through which the soul gazes and feasts on the beauty of the world; by reason of it the soul

is content with its human prison, and without it this human prison is
its torment; and by means of it human diligence has discovered fire by
which the eye wins back what the darkness has stolen from it. It has
adorned nature with agriculture and pleasant gardens. But what need is
there for me to indulge in long and elevated discourse? What thing is
there which acts not by reason of the eye? It impels men from the East
to the West; it has discovered navigation; and in this it excels
nature, because the simple products of the earth are finite and the
works which the eye makes over to the hands are infinite, as the
painter shows in his portrayal of countless forms of animals, herbs,
plants and places.

{85}

[Sidenote: Music the Sister of Painting]

24.

Music should be given no other name than the sister of painting,
inasmuch as it is subject to the hearing,--a sense inferior to the
eye,--and it produces harmony by the unison of its proportioned parts,
which are brought into operation at the same moment and are constrained
to come to life and die in one or more harmonic times; and time is, as
it were, the circumference of the parts which constitute the harmony,
in the same way as the outline constitutes the circumference of limbs
whence human beauty emanates.

But painting excels and lords over music because it does not die as soon as it is born, as occurs with music, the less fortunate; on the contrary, it continues to exist and reveals itself to be what it is, a single surface. O marvellous science, thou givest lasting life to the perished beauty of mortals, which are thus made more enduring than the works of nature, for these undergo forever the changes of time, and time leads them to inevitable old age! And this science is to divine nature as its works are to the works of nature, and on this account it is worshipped.

[Sidenote: Painting & Music]

25.

The most worthy thing is that which satisfies the most worthy sense; therefore painting, which satisfies the sense of sight, is more worthy than {86} music, which merely satisfies the hearing. The most worthy thing is that which endures longest; therefore music, which is continually dying as soon as it is born, is less worthy than painting, which lasts eternally with the colours of enamel. The most excellent thing is that which is the most universal and contains the greatest variety of things; therefore painting must be set above all other arts, because it contains all the forms which exist and also those which are not in nature, and it should be glorified and exalted more than music, which deals with the voice only.

With it images are made to the gods; around it divine worship is conducted, of which music is a subservient ornament; by means of it pictures are given to lovers of their beloved; by it the beauties are preserved which time, and nature the mother, render fitful; by it we retain the images of famous men. And if thou wert to say that by committing music to writing you render it eternal, we do the same with letters.

Therefore, since thou hast included music among the liberal arts, thou must either exclude it, or include the art of letters. And if thou wast to say: Painting is used by base men, in the same way is music spoilt by him who knows it not. If thou sayest that sciences which are not mechanical are mental, I will answer that painting is mental. And just as music and geometry deal with the proportions of continuous quantities, and {87} arithmetic deals with discontinuous quantities, painting deals with all quantities and the qualities of the proportions of shadows, lights and distances, in its perspective.

[Sidenote: Painter and Musician]

26.

The musician says that his art can be compared with that of the painter because by the art of the painter a body of many members is composed, and the spectator apprehends its grace in as many harmonious rhythms ... as there are times in which it lives and dies; and by these rhythms

... its grace plays with the soul, which dwells in the body of the spectator. But the painter replies that the body composed of human limbs does not afford the delectable harmonious rhythms in which beauty must live and die, but renders it permanent for many years, and is of such great excellence that it preserves the life of this harmony of concordant limbs which nature with all her force could not preserve.

How many pictures have preserved the semblance of divine beauty of which time or death had in a brief space destroyed the living example: and the work of the painter has become more honoured than that of nature, his master!

If thou, O musician, sayest that painting is mechanical because it is wrought by the work of the hands, music is wrought by the mouth, but {88} not by the tasting faculties of the mouth; just and as the hand is employed indeed in the case of painting, but not for its faculties of touch. Words are less worthy than actions. But thou, writer of science, dost thou not copy with thy hand, and write what is in thy mind, as the painter does? And if thou wast to say that music is formed of proportion, by proportion have I wrought painting, as thou shalt see.

[Sidenote: Poet Painter and Musician]

27.

There is the same difference between the representation of the embodied

works of the painter and those of the poet as there is between complete

and dismembered bodies, because the poet in describing the beauty or

the ugliness of any body reveals it to you limb by limb and at diverse

times, and the painter shows the whole at the same time. The poet

cannot express in words the true likeness of the limbs which compose a

whole, as can the painter, who places it before you with the truth of

nature. And the same thing befalls the poet as the musician, who sings

by himself a song composed for four singers; and he sings the treble

first, then the tenor, then the alto and then the bass, whence there

results no grace of harmonious concord such as harmonious rhythms

produce. And the poet is like a beautiful countenance which reveals

itself to you feature by feature, that by so doing you may never be

{89} satisfied by its beauty, which consists of the divine proportion

of the limbs united one with another, and these compose of themselves

and at one time the divine harmony of this union of limbs, and often

deprives the gazer of his liberty. Music, again, by its harmonious

rhythm, produces the sweet melodies formed by its various voices, and

their harmonious division is lacking to the poet; and although poetry

enters into the abode of the intellect by the channel of the hearing,

as does music, the poet cannot describe the harmony of music, because

it is not in his power to say various things in one and the same moment

as can the harmonious concord of painting, which is composed of various

members which exist simultaneously, and the beauty of these parts is

apprehended at the same time, individually and

collectively,--collectively with regard to the whole, individually with

regard to the component parts of which the whole is formed; and for

this reason the poet is, as far as the representation of bodily things is concerned, greatly inferior to the painter, and as far as invisible things are concerned he is far behind the musician. But if the poet borrows the aid of the other sciences, he can appear at the fair like the other merchants, bearers of divers goods made by many artificers; and the poet does this when he borrows the science of others, such as that of the orator, the philosopher, the astrologer, the cosmographer and {90} the like; and these sciences are altogether alien to the poet. Therefore he is an agent who brings together diverse persons in order to strike a bargain; and if you wish to know the true function of the poet, you will find that he is no other than an assembler of goods stolen from other sciences, with which he makes a deceptive mixture, or more honestly said, a fictitious mixture. And with regard to this fiction the poet is free to compete with the painter, since it constitutes the least part of the painting.

28.

The painter emulates and competes with nature.

[Sidenote: Painting a second Creation]

29.

He who blames painting blames nature, because the works of the painter

represent the works of nature, and for this reason he who blames in this fashion lacks feeling.

[Sidenote: The Painter Lord of All]

30.

If the painter wishes to see beautiful things which will enchant him he is able to beget them; if he wishes to see monstrous things which terrify, or grotesque and laughable things, or truly piteous things, he can dispose of all these; if he wishes to evoke places and deserts, shady or dark retreats in the hot season, he represents them, and likewise warm places in the cold season. If he wishes valleys, if he wishes to descry a great {91} plain from the high summits of the mountains, and if he wishes after this to see the horizon of the sea, he can do so; and from the low valleys he can gaze on the high mountains, or from the high mountains he can scan the low valleys and shores; and in truth all quantities of things that exist in the universe, either real or imaginary, he has first in his mind and then in his hands; and these things are of so great excellence that they beget a harmonious concord in one glance, as do the things of nature.

31.

We can safely say that those people are under a delusion who call that

painter a good master who can only draw well a head or a figure.

Certainly there is no great merit if, after studying a single thing

during a whole lifetime, you attain to a certain degree of perfection

in it. But knowing, as we do, that painting includes and comprehends

all the works produced by nature, or brought about by the fortuitous

action of man, and in fact everything that the eye can see, he seems to

me to be a poor master who can only do one thing well. Now seest thou

not how many and diverse acts are performed by men? Seest thou not how

many various animals there are, and likewise trees, plants and flowers;

what a variety of mountainous or level places, fountains, rivers,

cities, public and private buildings, {92} instruments suitable for

human use; how many diverse costumes and ornaments and arts? All these

things should be considered of equal effect and value when used by the

man who can be called a good painter.

[Sidenote: Painting and Nature]

32.

If you despise painting, which is the only imitator of the visible

works of nature, you will certainly despise a subtle invention which

with philosophy and subtle speculation apprehends the qualities of

forms, backgrounds, places, plants, animals, herbs and flowers, which

are surrounded by light and shade. And truly this is knowledge and the

legitimate offspring of nature, because painting is begotten by nature.

But to be correct, we will say that it is the grandchild of nature,

because all visible things are begotten by nature, and these her
children have begotten painting. Therefore we shall rightly say that
painting is the grandchild of nature and related to God.

33.

Were a master to boast that he could remember all the forms and effects
of nature, he would certainly appear to me to be graced with great
ignorance, inasmuch as these effects are infinite and our memory is not
sufficiently capacious to retain them. Therefore, O painter, beware
lest in thee the lust of gain should overcome the honour of thy art,
for the acquisition of honour is a much {93} greater thing than the
glory of wealth. Thus, for this and for other reasons which could be
given, first strive in drawing to express to the eye in a manifest
shape the idea and the fancy originally devised by thy imagination;
then go on adding or removing until thou art satisfied; then arrange
men as models, clothed or nude, according to the intention of thy work,
and see that, as regards dimension and size, in accordance with
perspective there is no portion of the work which is not in harmony
with reason and natural effects, and this will be the way to win honour
in thy art.

[Sidenote: Painting & Sculpture]

34.

I have myself practised the art of sculpture as well as that of painting, and I have practised both arts in the same degree. I think, therefore, that I can give an impartial opinion as to which of the two is the most difficult: the most perfect requires the greater talent, and is to be preferred.

In the first place sculpture requires a certain light, that is to say, a light from above, and painting carries everywhere with it its light and shade; sculpture owes its importance to light and shade. The sculptor is aided in this by the relief which is inherent in sculpture, and the painter places the light and shade, by the accidental quality of his art, in the places where nature would naturally produce it. The sculptor cannot diversify his work by the various colours of objects; painting {94} is complete in every respect. The perspective of the sculptor appears to be altogether untrue; that of the painter can give the idea of a distance of a hundred miles beyond the picture. The sculptors have no aerial perspective; they can neither represent transparent bodies nor reflections, nor bodies as lustrous as mirrors, and other translucent objects, neither mists nor dark skies, nor an infinity of objects which it would be tedious to enumerate. The advantage [of sculpture] is that it is provided with a better defence against the ravages of time, although a picture painted on thick copper and covered over with white enamel, painted with enamel colours and then put in the fire again and baked, is equally resistant. Such a work as far as permanence is concerned exceeds sculpture. They may say that where an error is made it is not easy to correct it. It is poor

reasoning to try and prove that the irremediability of an oversight renders the work more honourable. But I say to you that it will prove more difficult to mend the mind of the master who commits such errors than to repair the work he has spoilt. We know well that an experienced and competent artist will not make mistakes of this kind; on the contrary, acting on sound rules, he will remove so little at a time that his work will be brought to a successful close. Again, the sculptor, if he works in clay or wax, can remove and add, and when the work is finished it can be easily {95} cast in bronze, and this is the last and most permanent operation of sculpture, inasmuch as that which is merely of marble is liable to destruction, but this is not the case with bronze. Therefore the picture painted on copper, which with the methods of painting can be reduced or added to, is like bronze, which when it was in the state of a wax model could be reduced or added to. And if sculpture in bronze is durable, this copper and enamel work is more imperishable still; and while the bronze remains black and ugly, this is full of various and delectable colours of infinite variety, as we have described above. If you wish to confine the discussion to painting on panel I am content to pronounce between it and sculpture, saying, that painting is the more beautiful, the more imaginative and the more copious, and that sculpture is more durable, but has no other advantage. Sculpture with little labour shows what in painting seems to be a miraculous thing to do: to make impalpable objects appear palpable, to give the semblance of relief to flat objects, and distance to objects that are near. In fact painting is full of infinite resources of which sculpture cannot dispose.

35.

Sculpture is not a science, but a mechanical art, because it causes the
brow of the artist who practises it to sweat, and wearies his body; and
for {96} such an artist the simple proportions of the limbs, and the
nature of movements and attitudes, are all that is essential, and there
it ends, and shows to the eye what it is, and it does not cause the
spectator to wonder at its nature, as painting does, which in a plane
by its science shows vast countries and far-off horizons.

36.

The only difference between painting and sculpture is that the sculptor
accomplishes his work with the greater bodily fatigue, and the painter
with the greater mental fatigue. This is proved by the fact that the
sculptor in practising his art is obliged to exert his arms and to
strike and shatter the marble or other stone, which remains over and
above what is needed for the figure which it contains, by manual
exercise, accompanied often by profuse sweating, mingled with dust and
transforming itself into dirt; and his face is plastered and powdered
with the dust of the marble, so that he has the appearance of a baker,
and he is covered with minute chips, and it appears as if snow had
fallen on him, and his dwelling is dirty and full of chips and the dust
of stone.

The contrary occurs in the case of the painter,--we are speaking of excellent painters and sculptors,--since the painter with great leisure sits before his work well clothed, and handles the light brush dipped in lovely colours. He wears {97} what garments he pleases; his dwelling is full of beautiful pictures, and it is clean; sometimes he has music or readers of diverse and pleasant works, which, without any noise of hammers or other confused sounds, are heard with great pleasure.

37.

There can be no comparison between the talent, art and theory of painting and that of sculpture, which leaves perspective out of account,--perspective which is produced by the quality of the material and not of the artist. And if the sculptor says that he cannot restore the superabundant substance which has once been removed from his work, I answer that he who removes too much has but little understanding and is no master. Because if he has mastered the proportions he will not remove anything unnecessarily; therefore we will say that this disadvantage is inherent in the artist and not in the material. But I will not speak of such men, for they are spoilers of marble and not artists.

Artists do not trust to the judgement of the eye, because it is always deceptive, as is proved by him who wishes to divide a line into two equal parts by the eye, and is often deceived in the experiment;

wherefore the good judges always fear--a fear which is not shared by the ignorant--to trust to their own judgement, and on this account they proceed by continually checking the {98} height, thickness and breadth of each part, and by so doing accomplish no more than their duty. But painting is marvellously devised of most subtle analyses, of which sculpture is altogether devoid, since its range is of the narrowest. To the sculptor who says that his science is more lasting than that of painting, I answer that this permanence is due to the quality of the material and not to that of the sculptor, and the sculptor has no right to give himself the credit for it, but he should let it redound to nature which created the material.

38.

Painting has a wider intellectual range and is more wonderful and greater as regards its artistic resources than sculpture, because the painter is by necessity constrained to amalgamate his mind with the very mind of nature and to be the interpreter between nature and art, making with art a commentary on the causes of nature's manifestations which are the inevitable result of its laws; and showing in what way the likenesses of objects which surround the eye correspond with the true images of the pupil of the eye, and showing among objects of equal size which of them will appear more or less dark, or more or less clear; and among objects equally low which of them will appear more or less low; or among those of the same height which of them will appear more or less high; or among objects of equal size {99} placed at

119

various distances one from the other, why some will appear more clearly than others. And this art embraces and comprehends within itself all visible things, which sculpture in its poverty cannot do: that is, the colours of all objects and their gradations; it represents transparent objects, and the sculptor will show thee natural objects without the painter's devices; the painter will show thee various distances with the gradations of colour producing interposition of the air between the objects and the eye; he will show thee the mists through which the character of objects is with difficulty descried; the rains which clouded mountains and valleys bring with them; the dust which is inherent to and follows the contention between these forces; the rivers which are great or small in volume; the fishes disporting themselves on the surface or at the bottom of these waters; the polished pebbles of various colours which are collected on the washed sands at bottom of rivers surrounded by floating plants beneath the surface of the water; the stars at diverse heights above us; and in the same manner other innumerable effects to which sculpture cannot attain.

39.

Sculpture lacks the beauty of colours, the perspective of colours; it lacks perspective and it confuses the limits of objects remote from the {100} eye, inasmuch as it represents the limits of objects that are near in the same way as those of distant objects; it does not represent the air which, interposed between the eye and the remote object, conceals that object but as the veils in draped figures, which reveal

120

the naked flesh beneath them; it cannot represent the small pebbles of various colours beneath the surface of the transparent waters.

[Sidenote: To the Painter]

40.

And thou, painter, who desirest to achieve the highest excellence in practice, understand that unless thou build it on the solid foundations of nature, thou shalt reap but scant honour and gain by thy work; and if thy foundation is sound, thy works shall be many and good, and bring great honour to thee, and be of great profit.

41.

When the work exceeds the ideal of the artist, the artist makes scant progress; and when the work falls short of his ideal it never ceases to improve, unless avarice be an obstacle.

42.

He is a poor disciple who does not surpass his master.

43.

He is a poor master whose work is exalted in his {101} own opinion, and he is on the road to perfection in art whose work falls short of his ideal.

44.

Small rooms or dwellings help the mind to concentrate itself; large rooms are a source of distraction.

45.

The painter should be solitary, and take note of what he sees and reason with himself, making a choice of the more excellent details of the character of any object he sees; he should be like unto the mirror, which takes the colours of the objects it reflects. And this proceeding will seem to him to be a second nature.

[Sidenote: The Painter in his Studio]

46.

In order that the favourable disposition of the mind may not be injured by that of the body, the painter or the draughtsman should be solitary, and especially when he is occupied with those speculations and thoughts which continually rise up before the eye, and afford materials to be treasured by the memory.

If thou art alone, thou wilt belong to thyself only: if thou hast but one companion, thou wilt only half belong to thyself, and ever less in proportion to the indiscretion of his conduct; and if thou hast many companions, thou wilt encounter {102} the same disadvantage. And if thou shouldst say: "I will follow my own inclination, I will withdraw into seclusion in order the better to study the forms of natural objects"--I say thou wilt with difficulty be able to do this, because thou wilt not be able to refrain from constantly listening to their chatter; and, not being able to serve two masters, thou wilt play the part of a companion ill, and still worse will be the evil effect on thy studies in art. And if thou sayest: "I will withdraw myself, so that their words cannot reach and disturb me"--I, with regard to this, say thou wilt be regarded as a madman; but seest thou not that by so doing thou wilt be alone also?

[Sidenote: Advice to the Painter]

47.

The mind of the painter must be like unto a mirror, which ever takes

the colour of the object it reflects, and contains as many images as

there are objects before it. Therefore realize, O painter, that thou

canst not succeed unless thou art the universal master of imitating by

thy art every variety of nature's forms, and this thou canst not do

save by perceiving them and retaining them in thy mind; wherefore when

thou walkest in the country let thy mind play on various objects,

observe now this thing and now that thing, making a store of various

objects selected and chosen from those of lesser value. And thou shalt

not do as some painters, who, when weary of plying {103} their fancy,

dismiss their work from their mind and take exercise in walking for

relaxation, but retain fatigue in the mind, which, though they see

various objects, does not apprehend them, but often when they meet

friends and relations and are saluted by them, they are no more

conscious of them than if they had met empty air.

[Sidenote: Precepts]

48.

And thou, O painter, seek to bring about that thy works may attract

those who gaze upon them and arrest them with great admiration and

delight; and so that they may not attract and forthwith repel them, as

the air does to him who in the night season leaps naked from his bed to

gaze upon the cloudy and serene sky and forthwith is driven back by the

cold, and returns to the bed whence he rose. But let thy works be like

124

the air which draws men from their beds in the hot season, and retains

them to taste with delight the cool of the summer; and he who will do

well by his art will not strive to be more skilful than learned, nor

let greed get the better of glory. Seest thou not among human beauties

that it is the beautiful faces which stop the passers-by, and not the

richness of their ornaments? And this I say to thee who adornest thy

figures with gold and other rich ornaments: Seest thou not splendid,

youthful beauties, who diminish their excellence by the excess and

elaboration of their {104} ornaments? Hast thou not seen women of the

mountains dressed in rough and poor clothes richer in beauty than those

who are adorned? Make no use of the affected arrangements and

headdresses such as those adopted by loutish maids, who, by placing one

lock of hair more on one side than the other, credit themselves with

having committed a great enormity, and think that the bystanders will

forget their own thoughts to talk of them alone, and to blame them.

For such persons have always the looking-glass and the comb, and the

wind, which ruffles elaborate headdresses, is their worst enemy. In

thy heads let the hair sport with the wind thou depictest around

youthful countenances, and adorn them gracefully with various turns,

and do not as those who plaster their faces with gum and make the faces

seem as if they were of glass. This is a human folly which is always

on the increase, and the mariners do not satisfy it who bring arabic

gums from the East, so as to prevent the smoothness of the hair from

being ruffled by the wind,--but they pursue their investigations still

further in this direction.

49.

I cannot but mention among these precepts a new means of study, which, although it may seem trivial and almost ridiculous, is nevertheless extremely useful in arousing the mind to {105} various inventions. It is as follows: when you look at walls mottled with various stains or stones made of diverse substances, if you have to invent some scene, you may discover on them the likeness of various countries, adorned with mountains, rivers, rocks, trees, plains, great valleys and hills in diverse arrangement; again, you may be able to see battles and figures in action and strange effects of physiognomy and costumes, and infinite objects which you could reduce to complete and harmonious forms. And the effect produced by these mottled walls is like that of the sound of bells, in the vibrating of which you may recognize any name or word you choose to imagine. I have seen blots in the clouds and in mottled walls which have stimulated me to the invention of various objects, and although the blots themselves were altogether devoid of perfection in any one of their parts, they lacked not perfection in their movement and circumstance.

50.

Obtain knowledge first, and then proceed to practice, which is born of knowledge.

51.

Knowledge is the captain, and practice the soldiers.

52.

The painter who draws by practice and by the {106} eye, without the guide of reason, is like the mirror, which reflects all the objects which are placed before it and knows not that they exist.

53.

Many will consider they can reasonably blame me by alleging that my proofs are contrary to the authority of many men held in great esteem by their inexperienced judgements: overlooking the fact that my works are solely and simply the offspring of experience, which is the veritable master.

54.

They who are enamoured of practice without knowledge are like the mariner who puts to sea in a vessel without rudder or compass, and who

navigates without a course. Practice should always be based on sound theory; perspective is the guide and the portal of theory, and without it nothing can be well done in the art of painting.

[Sidenote: Course of Study]

55.

The youth should first learn perspective, and then the measurements of every object; he should then copy from some good master to accustom himself to well-drawn forms, then from nature to acquire confirmation of the theories he has learnt; then he should study for a time the works of various masters, and finally attain the {107} habit of putting into practice and producing his art.

56.

Mathematics, such as appertain to painting, are necessary to the painter, also the absence of companions who are alien to his studies: his brain must be versatile and susceptible to the variety of objects which it encounters, and free from distracting cares. And if in the contemplation and definition of one subject a second subject intervenes,--as happens when the mind is filled with an object,--in such cases he must decide which of the two objects is the more difficult of definition, and pursue that one until he arrives at

perfect clearness of definition, and then turn to the definition of the other. And above all things his mind should be like the surface of the mirror, which shows as many colours as there are objects it reflects; and his companions should study in the same manner, and if such cannot be found he should meditate in solitude with himself, and he will not find more profitable company.

[Sidenote: Perspective & Mathematics]

57.

In the study of natural causes and reasons light affords the greatest pleasure to the student; among the great facts of mathematics the certainty of demonstration most signally elevates the mind of the student. Perspective must therefore be {108} placed at the head of all human study and discipline, in the field of which the radiant line is rendered complex by the methods of demonstration; in it resides the glory of physics as well as of mathematics, and it is adorned with flowers of both these sciences.

The laws of those sciences which are capable of extensive analysis I will confine in brief conclusions, and according to the nature of the material I will interweave mathematical demonstrations, at times deducing results from causes, and at times tracing causes by results. I will add to my conclusions some which are not contained in these, but which can be deduced from them, if the Lord, the Supreme Light,

illuminates me, so that I may treat of light.

[Sidenote: Of the Method of Learning]

58.

When you will have thoroughly mastered perspective and have learnt by heart the parts and forms of objects, strive when you go about to observe. Note and consider the circumstances and the actions or men, as they talk, dispute, laugh or fight together, and not only the behaviour of the men themselves, but that of the bystanders who separate them or look on at these things; and make a note of them, in this way, with slight marks in your little note-book. And you should always carry this note-book with you, and it should be of coloured paper, so that what you {109} write may not be rubbed out; but (when it is used up) change the old for a new one, since these things should not be rubbed out, but preserved with great care, because such is the infinity of the forms and circumstances of objects, that the memory is incapable of retaining them; wherefore keep these sketches as your guides and masters.

59.

These rules are only to be used in correcting the figures, since every man makes some mistakes in his first composition, and he who is not

aware of them cannot correct them; but thou being conscious of thine errors wilt correct thy work and amend errors where thou findest them, and take care not to fall into them again. But if thou attemptest to apply these rules in composition thou wilt never finish anything, and confusion will enter into thy work. Through these rules thou shalt acquire a free and sound judgement, since sound judgement and thorough understanding proceed from reason arising from sound rules, and sound rules are the offspring of sound experience, the common mother of all the sciences and arts. Hence if thou bearest in mind the precepts of my rules thou shalt be able, merely by thy corrected judgement, to judge and recognize any lack of proportion in a work, in perspective, in figures or anything else.

{110}

[Sidenote: Again of the Method of Learning]

60.

I say that the first thing which should be learnt is the mechanism of the limbs, and when this knowledge has been acquired their actions should come next, according to the external circumstances of man, and thirdly the composition of subjects, which should be taken from natural actions, made fortuitously according to circumstances; and pay attention to them in the streets and public places and fields, and note them with a brief indication of outlines; that is to say, for a head make an O, and for an arm a straight or a bent line, and the same for

the legs and body; and when thou returnest home work out these notes in a complete form. The adversary says that to acquire practice and to do a great deal of work, it is better that the first course of study should be employed in copying diverse compositions done on paper or on walls by various masters, and that thus rapidity of practice and a good method is acquired; to which I reply that this method will be good if it is based on works which are well composed by competent masters; and since such masters are so rare that but few of them are to be found, it is safer to go to nature, than to what to its deterioration is imitated from nature, and to fall into bad habits, since he who can go to the fountain does not go to the water-vessel.

{111}

[Sidenote: Counsel to the Painter]

61.

Every bough and every fruit is born above the insertion of its leaf, which serves it as a mother, giving it water from the rain and moisture from the dew which falls on it from above in the night, and often it shields them from the heat of the sun's rays. Therefore, O painter, who lackest such rules, be desirous, in order to escape the blame of those who know, of copying every one of thy objects from nature, and despise not study after the manner of those who work for gain.

62.

And you who say that it would be better to see practical anatomy than

drawings of it, would be right if it were possible to see all the

things which are shown in such drawings in a single drawing, in which

you, with all your skill, will not see nor obtain knowledge of more

than a few veins; and to obtain true and complete knowledge of these

veins I have destroyed more than ten human bodies, destroying all the

other limbs, and removing, down to its minutest particles, the whole of

the flesh which surrounds these veins, without letting them bleed save

for the insensible bleeding of the capillary veins. And as one body

did not suffice for so long a time I had to proceed with several bodies

by degrees until I finished by acquiring perfect knowledge, and this I

{112} repeated twice to see the differences. And if you have a love

for such things you may be prevented by disgust, and if this does not

prevent you, you may be prevented by fear of living at night in company

with such corpses, which are cut up and flayed and fearful to see; and

if this does not prevent, you may not have a sufficient mastery of

drawing for such a demonstration, and if you have the necessary mastery

of drawing, it may not be combined with the knowledge of perspective;

and if it were you might lack the power of geometrical demonstration,

and the calculation of forces, and of the strength of the muscles, and

perhaps you will lack patience and consequently diligence. As to

whether these qualities are to be found in me or not the hundred and

twenty books I have composed will pronounce the verdict Yes or No.

Neither avarice nor negligence, but time has hindered me in these. Farewell.

[Sidenote: On Study]

63.

I have myself proved that it is useful when you are in bed in the dark to work with the imagination, summing up the external outlines of the forms previously studied or other noteworthy things apprehended by subtle speculation; and this is a laudable practice and useful in impressing objects on the memory.

{113}

[Sidenote: On judging Pictures]

64.

We are well aware that faults are more easily recognized in the works of others than in our own, and often in blaming the small faults of others thou wilt ignore great ones in thyself. And to avoid such ignorance see that in the first place thy perspective be sound, then acquire a complete knowledge of the measurements of man and other animals, and of good architecture; that is to say, as far as the forms

of buildings and other objects which are on the earth are concerned,
and these are infinite in number. The more of them that thou knowest,
the more praiseworthy will be thy work; and in cases where thou hast no
experience do not refuse to draw them from nature.

[Sidenote: Advice to the Painter]

65.

Certainly while a man is painting he should not be loth to hear every
opinion: since we know well that a man, although he be not a painter,
is cognizant of the forms of another man, and will be able to judge
them, whether he is hump-backed or has a shoulder too high or too low,
or whether he has a large mouth or nose, or other defects. And if we
know that men are capable of giving a correct judgement on the works of
nature, much more ought we to acknowledge their competence to judge our
faults, since we know how greatly a man may be deceived in {114} his
own work; and if thou art not conscious of this in thyself, study it in
others and thou wilt profit by their faults. Therefore be desirous to
bear with patience the opinions of others, and consider and reflect
well whether he who blames has good ground or not to blame thee, and if
thou thinkest that he has, amend thy work; and if not, act as though
thou hadst not heard him, and if he should be a man thou esteemest show
him by reasoning where his mistake lies.

66.

There is a certain generation of painters who, owing to the scantiness of their studies, must needs live up to the beauty of gold and azure, and with supreme folly declare that they will not give good work for poor payment, and that they could do as well as others if they were well paid. Now consider, foolish people! Cannot such men reserve some good work and say, "This is costly; this is moderate, and this is cheap work," and show that they have work at every price?

[Sidenote: The Painter and the Mirror]

67.

When thou wishest to see whether thy picture corresponds entirely with the objects thou hast drawn from nature, take a mirror and let the living reality be reflected in it, and compare the reflection with thy picture, and consider well {115} whether the subject of the two images are in harmony one with another.

And above all thou shouldst take the mirror for thy master,--a flat mirror, since on its surface the objects in many respects have the same appearance as in painting. For thou seest that a painting done on a flat surface reveals objects which appear to be in relief, and the mirror consisting of a flat surface produces the same effect; the painting consists of one plane surface and the mirror likewise; the

picture is impalpable, in so far as that which appears to be round and prominent cannot be grasped by the hands, and it is the same with the mirror; the mirror and the painting reveal the semblance of objects surrounded by light and shade; each of them appears to be at a distance from its surface.

And if thou dost recognize that the mirror by means of outlines, lights and shadows gives relief to objects, and since thou hast in thy colours lights and shadows stronger than those of the mirror, there is no doubt that if thou composest thy picture well, it will also have the appearance of nature when it is reflected in a large mirror.

[Sidenote: The Painter's Mind]

68.

The mind of the painter should continually transmute the figure of the notable objects which come before him into so many discourses; and imprint them in his memory and classify them {116} and deduce rules from them, taking the place, the circumstances, the light and the shade into consideration.

[Sidenote: The Variety of Nature]

69.

I say that the universal proportions must be observed in the height of figures and not in their size, because in the admirable and marvellous things which appear in the works of nature there is no work of whatsoever character in which one detail is exactly similar to another; therefore, O thou imitator of nature, pay heed to the variety of features.

70.

Radically wrong is the procedure of some masters who are in the habit of repeating the same themes in the same episodes, and whose types of beauty are likewise the same, for in nature they are never repeated, so that if all the beauties of equal excellence were to come to life again they would compose a larger population than that now existing in our century, and since in the present century no one person is precisely similar to another, so would it be among the beauties mentioned above.

71.

You must depict your figures with gestures which will show what the figure has in his mind, otherwise your art will not be praiseworthy.

{117}

72.

No figure will be admirable if the gesture which expresses the passion of the soul is not visible in it. The most admirable figure is that which best expresses the passion of its mind.

73.

The good painter has two principal things to depict: man and the purpose of his mind. The first is easy, the second is difficult, since he must do it by the gestures and movements of the limbs, and this is to be learnt from the dumb, who more than all other men excel in it.

[Sidenote: The Dumb Man guides the Painter]

74.

The figures of men have gestures which correspond to what they are doing, so that in seeing them you understand what they are thinking of and saying; and these will be learned well by him who will copy the gestures of the dumb, for they speak by the gestures of their hands, their eyes, their brows and their whole person, when they wish to

express the purpose of their mind. And do not mock me because I

suggest a dumb teacher for the teaching of an art of which he is

himself ignorant, because he will teach you better by his gestures than

all the others with their words. And despise not such advice because

they are the masters of gesture, and understand at a {118} distance

what a man is talking of if he suits the actions of the hands to the

words.

[Sidenote: Advice to the Painter]

75.

It is a great fault in painters to repeat the same movements, the same

faces and manners of stuffs in one subject, and to let the greater part

of his faces resemble their creator; and this has often been a source

of wonder to me, for I have known some who in all their figures seem to

have depicted themselves. And in the figures the actions and ways of

the painter were visible. And if they are prompt in action and in

their ways the figures are likewise prompt; and if the painter is

pious, the figures with their twisted necks appear pious likewise, and

if the painter is lazy the figures seem like laziness personified, and

if the painter is deformed so are his figures, and if he is mad it is

amply visible in figures of his subjects, which are devoid of intention

and appear to be heedless of their action, some looking in one

direction, some in another, as though they were dreaming; and therefore

every manifestation in the picture corresponds to a peculiarity in the

painter. And as I have often thought over the cause of this fault, it seems to me that we must conclude that the spirit which directs and governs everybody is that which forms our intellect, or rather, it is our intellect itself. It has {119} devised the whole figure of man according as it has thought fit that it should be, either with long or a short and turned-up nose, and thus it has determined its height and figure; and so powerful is the intellect that it gives motion to the arms of the painter and causes him to reproduce himself, since it appears to the spirit that this is the true method of portraying man, and he that does otherwise is in error. And should this spirit find any one who resembles its body, which it has formed, it loves it and becomes enamoured with it, and for this reason many men fall in love and marry wives which resemble themselves, and often the children which are born of the issue resemble their parents.

76.

The painter should portray his figure according to the measurements of a natural body, which shall be of universal proper proportions; in addition to this he should measure himself and see in which part his own figure varies greatly or less from the aforesaid pattern of excellence, and when he has ascertained this he should try his utmost to avoid the defects which exist in his own person in the figures he portrays.

And know that thou must contend with all thy might against this fault

inasmuch as it is a defect which originated with the intellect; because the {120} spirit which governs thy body is that which is thine own intellect, and it is inclined to take pleasure in works similar to that which it accomplished in forming its body. And this is the reason that there is no woman, however ugly, who does not find a lover, unless she be monstrous. So remember to ascertain the defects of thy person and to avoid reproducing them in the figures thou dost compose.

77.

That painter who has coarse hands will portray the like in his works, and the same thing will occur in every limb unless he avoids this pitfall by long study. Therefore, O painter, look well on that part of thy person which is most ugly, and by thy study make ample reparation for it, because if thou art bestial, bestial and without intellect will be thy figures, and similarly both the good and ill which thou hast in thee will be partially visible in thy compositions.

78.

Men and words are already made, and thou, painter, who knowest not how to make thy figures move, art like the orator who knows not how to employ his words.

79.

The movements of men are as varied as the {121} circumstances which pass through their minds; and men will be more or less actuated by every circumstance in itself according as they are more or less powerful and according to age; because in the same circumstance an old man or a youth will make a different movement.

[Sidenote: Power of Expression in Painting]

80.

The imagination does not perceive such excellent things as the eye, because the eye receives the images or semblances from objects, and transmits them to the perception, and from thence to the brain; and there they are comprehended. But the imagination does not issue forth from the brain, with the exception of that part of it which is transmitted to the memory, and in the brain it remains and dies, if the thing imagined is not of high quality. And in this case poetry is formed in the mind or in the imagination of the poet, who depicts the same objects as the painter, and by reason of the work of his fancy he wishes to rival the painter, but in reality he is greatly inferior to him, as we have shown above. Therefore with regard to the work of fancy we will say that there is the same proportion between the art of painting and that of poetry as exists between the body and the shadow proceeding from it, and the proportion is still greater, inasmuch as

the shadow of such a body at least penetrates to {122} the brain through the eye, but the imaginative embodiment of such a body does not enter into the eye, but is born in the dark brain. Ah! What difference there is between imagining such a light in the darkness of the brain and seeing it in concrete shape set free from all darkness.

If thou, O poet, dost represent the battle and its bloodshed enveloped by the obscure and dark air, amid the smoke of the terrifying and deadly engines, together with the thick dust which darkens the air, and the flight in terror of wretches panic-stricken by horrible death; in this case the painter will surpass thee, because thy pen will be used up before thou hast scarcely begun to describe what the art of the painter represents for thee immediately. And thy tongue shall be parched with thirst and thy body worn out with weariness and hunger before thou canst show what the painter will reveal in an instant of time. And in this painting there lacks nothing save the soul of the things depicted, and every body is represented in its entirety as far as it is visible in one aspect; and it would be a long and most tedious matter for poetry to enumerate all the movements of each soldier in such a war, and the parts of their limbs and their ornaments which the finished picture places before you with great accuracy and brevity; and to such a representation nothing is wanting save the noise of the engines, and the cries of the terrifying victors, {123} and the screams and lamentations of those awe-stricken; neither again can the poet convey these things to the hearing.

We will say, therefore, that poetry is an art which is supremely potent

for the blind, and the painting has the same result on the deaf.

Painting, therefore, excels poetry in proportion as the sense to which

it ministers is the nobler. The only true function of the poet is to

represent the words of people who talk among each other, and these

alone he represents to the hearing as if they were natural, because

they are natural in themselves and created by the human voice; and in

all other respects he is surpassed by the painter. Still more,

incomparably greater is the width of range of painting than that of

speech, because the painter can accomplish an infinity of things which

speech will not be able to name for want of the appropriate terms. And

seest thou not that if the painter wishes to depict animals and devils

in Hell with what richness of invention he proceeds?

And I once chanced to paint a picture which represented a divine

subject, and it was bought by the lover of her whom it represented, and

he wished to strip it of its divine character so as to be able to kiss

it without offence. But finally his conscience overcame his desire and

his lust and he was compelled to remove the picture from his house.

Now go thou, poet, and describe a beautiful woman without giving the

semblance of {124} the living thing, and with it arouse such desire in

men! If thou sayest: I will describe then Hell and Paradise and other

delights and terrors,--the painter will surpass thee, because he will

set before thee things which in silence will [make thee] give utterance

to such delight, and so terrify thee as to cause thee to wish to take

flight. Painting stirs the senses more readily than poetry. And if

thou sayest that by speech thou canst convulse a crowd with laughter or

tears, I rejoin that it is not thou who stirrest the crowd, it is the

pathos of the orator, and his mirth. A painter once painted a picture

which caused everybody who saw it to yawn, and this happened every time

the eye fell on the picture, which represented a person yawning.

Others have painted libidinous acts of such sensuality that they have

incited those who gazed on them to similar acts, and poetry could not

do this.

And if you write the description of certain deities the description

will not be held in the same veneration as the picture of the Deity,

because prayers and votive offerings will always be made to the

picture, and many peoples from diverse countries and from across the

Eastern seas will flock to it. And they will invoke the picture, and

not the writing, for succour. Who is he who would not lose hearing,

smell and touch rather than sight? Because he who loses his sight is

like the man who is driven from the world, because {125} he sees

neither it nor anything else any longer. And this life becomes the

sister of Death.

[Sidenote: Landscapes]

81.

I have been to see a variety of cloud effects, and lately over Milan

towards Lake Maggiore I saw a cloud in the form of a huge mountain full

of fiery scales, because the rays of the sun, which was already

reddening and close to the horizon, tinged the cloud with its own

colour. And this cloud attracted to it all the lesser clouds which

were around it; and the great cloud did not move from its place, but on

the contrary retained on its summit the light of the sun till an hour

and a half after nightfall, such was its immense size; and about two

hours after nightfall a great, an incredibly tremendous wind arose.

[Sidenote: Vegetation of a Hill]

82.

The grasses and plants will be paler in proportion as the soil which

nourishes them is leaner and devoid of moisture; the earth is leaner

and less rich in moisture on the rocks of which the mountains are

formed. And the trees will be smaller and thinner in proportion as

they are nearer to the summit of the mountain; and the soil is leaner

in proportion as it is nearer to the said summit, and it is richer in

proportion as it is nearer the hollow valleys. Therefore, O painter,

{126} thou shalt represent rocks on the summits of the mountains--for

they are composed of rocks--for the greater part devoid of soil, and

the plants which grow there are small and lean and for the greater part

withered and dry from lack of moisture, and the sandy and lean earth is

seen through the faded plants; and the small plants are stunted and

aged, exiguous in size, with short and thick boughs and few leaves;

they cover for the greater part the rust-coloured and dry roots, and

are interwoven in the strata and the fissures of the rugged rocks, and

issue from trunks maimed by men or by the winds; and in many places you

see the rocks surmounting the summits of the high mountains, covered
with a thin and faded moss; and in some places their true colour is
laid bare and made visible owing to the percussion of the lightnings of
Heaven, whose course is often obstructed to the damage of these rocks.

And in proportion as you descend towards the base of the mountains the
plants are more vigorous and their boughs and foliage are denser; and
their vegetation varied according to the various species of the plants
of which such woods are composed, and their boughs are of diverse
arrangement and diverse amplitude of foliage, various in shape and
size; and some have straight boughs like the cypress, and some have
widely scattered and spreading boughs like the oak and the chestnut
tree, and the like; some have very {127} small leaves, others have a
spare foliage like the juniper and the plane tree, and others; some
plants born at the same time are divided by wide spaces, and others are
united with no division of space between them.

[Sidenote: How to represent Night]

83.

That which is entirely devoid of light is all darkness; as the night is
like this and you wish to represent a night subject, represent a great
fire, so that the object which is nearest to the fire may be tinged
with its colour, since the object which is nearest the fire will
participate most in its nature. And as you will make the fire red, all

the objects which it illumines must be red also, and those which are farther off from the fire will be dyed to a greater extent by the dark colour of night. The figures which are between you and the fire appear dark from the obscurity of the night, not from the glow of the firelight, and those which are at the side are half dark and half ruddy, and those which are visible beyond the edge of the flames will be altogether lighted up by the red glow against a black background. As to their action, make those which are near shield themselves with their hands and cloaks against the intense heat with averted faces as though about to flee; with regard to those who are farther off, represent them chiefly in the act of raising their hands to their eyes, dazzled by the intense glare.

{128}

[Sidenote: How to represent Storm]

84.

If you wish to represent well a storm, consider and weigh its effects when the wind, blowing across the surface of the sea and the earth, removes and carries with it those things which are not stable in the universal drift. And in order to represent this storm adequately, you must in the first place represent tattered and rent clouds rushing with the rushing wind, accompanied by sandy dust caught up from the seashores, and boughs and leaves torn up by the force and fury of the wind, and dispersed in the air with many other light objects. The

149

trees and the plants bent towards the earth almost seem as though they wished to follow the rushing wind, with their boughs wrenched from their natural direction and their foliage all disordered and distorted. Of the men who are to be seen, some are fallen and entangled in their clothes and almost unrecognizable on account of the dust, and those who remain standing may be behind some tree, clutching hold of it so that the wind may not tear them away; others, with their hands over their eyes on account of the dust, stoop towards the ground, with their clothes and hair streaming to the wind. The sea should be rough and tempestuous, and full of swirling eddies and foam among the high waves, and the wind hurls the spray through the tumultuous air like a thick and swathing mist. {129} As regards the ships that are there, you will depict some with torn sails and tattered shreds fluttering through the air with shattered rigging; some of the masts will be split and fallen, and the ship lying down and wrecked in the raging waves; some men will be shrieking and clinging to the remnants of the vessel. You will make the clouds driven by the fury of the winds and hurled against the high summits of the mountains, and eddying and torn like waves beaten against rocks; the air shall be terrible owing to deep darkness caused by the dust and the mist and the dense clouds.

[Sidenote: How to describe a Battle]

85.

In the first place you must represent the smoke of the artillery

150

mingled with the air, and the dust, and tossed up by the stampede of the horses and the combatants. And you must treat this confusion in this way: dust being an earthly thing has weight, and although owing to its fineness it is easily lifted up and mingled with the air, it nevertheless falls readily to the earth again, and it is its finest part which rises highest, therefore that part will be the least visible and will seem to be almost of the same colour as the air; the higher the smoke, which is mingled with the dusty air, rises towards a certain height, the more it will seem like a dark cloud, and at the summit the smoke will be more visible than the dust. {130} The smoke will assume a bluish colour, and the dust will retain its colour: this mixture of air, smoke and dust will seem much brighter on the side whence the light proceeds than on the opposite side; the more densely the combatants are enveloped in this confusion the less distinctly will their lights and shadows be visible. You must cast a glowing light on the countenances and the figures, the atmosphere, the musketeers and those who are near them, and this light diminishes in proportion as the distance between it and its cause increases; and the figures which are between you and the light will appear dark against a bright background, and their legs will be less visible in proportion as they are nearer to the earth, because the dust there is coarsest and thickest. And if you depict horses galloping beyond the crowd, make little clouds of dust, distant one from the other in proportion to the strides made by the horses, and the cloud which is farthest away from the horse will be the least visible; it must be high, scattered and thin, and the nearer clouds will be more conspicuous, smaller and denser. The air must be full of arrows falling in every direction: some flying upwards, some

151

falling, some on the level plane; and smoke should trail after the

flight of the cannon-balls. The foremost figures should have their

hair and eyebrows clotted with dust; dust must be on every flat portion

they offer capable of retaining it. {131} The conquerors you should

make as they charge, with their hair and the other light things

appertaining to them streaming to the wind, their brows contracted and

the limbs thrust forward inversely, that is, if the right foot is

thrust forward the left arm must be thrust forward also. And if you

portray a fallen man you must show where he has slipped and been

dragged through the blood-stained mud, and around in the wet earth you

must show the imprint of the feet of men and the hoofs of horses that

have passed there. You will also represent a horse dragging its dead

master, and in the wake of the body its track, as it has been dragged

along through the dust and the mud; you must make the vanquished and

beaten pale, their brows knit and the skin surmounting the brow

furrowed with lines of pain. On the sides of the nose there must be

wrinkles forming an arch from the nostrils to the eyes and terminating

at the commencement of the latter; the nostrils should be drawn up,

whence the wrinkles mentioned above; the arched lips show the upper row

of teeth. The teeth should be apart, as with crying and lamentation.

One hand shields the frightened eyes, the palm being held towards the

enemy; the other [hand] rests on the ground to sustain the raised body.

You shall portray others shouting in flight with their mouths wide

open; you must depict many kinds of weapons lying at the feet of the

{132} combatants, such as broken shields, lances, shattered swords and

other similar objects; you must portray dead men, some half covered,

some entirely covered, by the dust which is mingled with the spilt

blood and converted into red mud, and the blood is seen by its colour flowing in a sinuous stream from the body to the dust; others in their death-agony are grinding their teeth, rolling their eyes and clenching their fists against their bodies and their distorted legs. Some might be represented disarmed and thrown by the enemy, turning upon him with teeth and nails to wreak cruel and sharp revenge; a riderless horse might be represented charging with his mane streaming to the wind amidst the enemy, and inflicting great damage with his hoofs. Some maimed man might be seen fallen to the earth and protecting himself with his shield, while the enemy, bending over him, tries to kill him. You might show a number of men fallen together over a dead horse. You would see some of the conquerors leaving the battle and issuing from the crowd, clearing with their hands their eyes and cheeks of the mud made by the watering of their dust-bespattered eyes. You would see the reserves standing full of hope and caution, with brows alert, shading them with their hands and gazing through the thick and confused darkness, attentive to the orders of their captain; and likewise the captain, with his staff raised, is rushing towards these {133} reserves and points out to them the spot where they are needed; and you may add a river with horses charging into it and stirring up the water all round them into seething waves of mixed foam and water, which is spurted into the air and among the legs and bodies of the horses. And there must not be a level place that is not trampled with gory footsteps.

[Sidenote: Envy]

86.

Envy offends with false infamy, that is to say, by detraction which
frightens virtue. Envy must be represented with the hands raised to
heaven in contempt, because if she could she would use her power
against God. Make her face covered with a goodly mark; show her as
wounded in the eye by a palm-branch, and wounded in the ear by laurel
and myrtle, to signify that victory and truth offend her. Draw many
thunderbolts proceeding from her as a symbol of her evil-speaking.
Make her lean and shrivelled up, because she is continual dissolution.
Make her heart gnawed by a swelling serpent. Make her a quiver full of
tongues for arrows, because she often offends with these. Make her a
leopard's skin, because the leopard kills the lion through envy and by
deceit. Place a vase in her hand full of flowers, and let it be full
also of scorpions, toads and other reptiles. Let her ride Death,
because Envy, which is undying, never wearies of sovereignty. {134}
Make her a bridle loaded with divers arms, because her weapons are all
deadly. As soon as virtue is born it begets envy which attacks it; and
sooner will there exist a body without a shadow than virtue
unaccompanied by envy.

[Sidenote: Fame]

87.

Fame alone rises towards heaven, because God looks with favour on virtuous things; infamy must be represented upside down, because its works are contrary to God and move towards hell. Fame should be depicted covered with tongues instead of with feathers and in the form of a bird.

[Sidenote: The Expressive Picture]

88.

A picture or a representation of human figures should be done in such a way that the spectator can easily recognize the purpose that is in their minds by their attitudes. If you have to represent a man of high character, let his gestures be such as harmonize with fair words; likewise, if you have to represent a man of low character, let his gestures be fierce, let him thrust his arms towards the listener, and let his head and chest be thrust forward in front of his feet, following the hands of the speaker. It is thus with a dumb man, who seeing two speakers, although he is deprived of hearing, nevertheless, owing to the attitudes and gestures of the speakers,

understands the subject of their argument. I once saw at Florence a man who had become deaf by an accident, who, if you spoke loud to him, did not understand you, but if you spoke gently, without making any noise, he understood you merely by the movement of the lips. Now you can say, Does not one who talks loudly move his lips like one who talks

softly? In regard to this I leave experiment to decide: make a man

speak gently to you and note his lips.

[Sidenote: The Ages of Man]

89.

How the ages of man should be depicted: that is, infancy, childhood,

youth, manhood, old age, decrepitude. How old men should be depicted

with lazy and slow movements, their legs bent at the knees when they

stand still, and their feet placed parallel and apart, their backs

bent, their heads leaning forward and their arms only slightly extended.

How women should be represented in modest attitudes, their legs close

together, their arms folded together, their heads bent and inclined to

one side. How old women should be represented with eager, vehement and

angry gestures, like the furies of Hades; the movement of the arms and

the head should be more violent than that of the legs. Little children

with ready and twisted movements when sitting, and when standing up in

shy and timid attitudes.

{136}

90.

You will do as follows if you wish to represent a man talking to a

number of people: you must consider the matter which he has to treat, and suit his action to the subject; that is to say, if the matter is persuasive, let his action be appropriate to it; if the matter is argumentative, let the speaker hold one finger of the left hand with two fingers of the right hand, closing the two smaller ones, and with his face turned towards the people and his mouth half open, let him seem to be about to speak, and if he is sitting let him appear as though about to rise, with his head forward; if you represent him standing up, let him lean slightly forward, with his body and head towards the people. You must represent the people silent and attentive, looking at the orator's face with gestures of admiration, and depict some old men with the corners of their mouths pulled down in astonishment at what they hear, their cheeks drawn in and full of lines, their eyebrows raised, and thus causing a number of wrinkles on the forehead; again, some must be sitting with the fingers of their hands clasped and resting on their knee; another, a bowed old man, with one knee crossed over the other, and on the knee let him hold his hand, and let his other elbow rest on his hand, and let the hand support his bearded chin.

{137}

91.

You must represent an angry man holding some one by the ear, beating his head against the ground, with one knee on his ribs, his right arm

raising his fist in the air; his hair must be dishevelled, his eyebrows low and narrow, his teeth clenched and the two corners of his mouth set, his neck swelled and [his brow] wrinkled and bent forward as he leans over his enemy.

92.

The desperate man must hold a knife and must have torn open his garments, and with one hand he must be tearing open the wound; and you must represent him with extended feet and the legs slightly bent and his body leaning towards the earth, his hair flying and dishevelled.

[Sidenote: Notes on the Last Supper]

93.

One who was in the act of drinking leaves his glass in its place, and turns his head towards the speaker. Another, twisting the fingers of his hands together, turns with stern brows to his companions. Another, with his hands spread out, shows their palms, and shrugs his shoulders towards his ears; his mouth expresses amazement. Another speaks in the ear of his neighbour, and he, as he listens to him, turns towards him, lending him his ear, while he holds a knife in one hand and {138} a piece of bread in the other, half cut through by the knife. Another, in turning with a knife in his hand, has upset a glass on the table.

Another lays his hands on the table and looks fixedly. Another puffs

out his cheeks, his mouth full. Another leans forward to see the

speaker, shading his eyes with his hand. Another draws back behind him

who is leaning forward and sees the speaker between the wall and the

man who is leaning forward.

{141}

III

THOUGHTS ON SCIENCE

* *

*

[Sidenote: Necessity of Experience in Science]

There is no human experience that can be termed true science unless it

can be mathematically demonstrated. And if thou sayest that the

sciences which begin and end in the mind are true, this cannot be

conceded, but must be denied for many reasons, and firstly because in

such mental discourses experience is eliminated, and without experience

there can be no certainty.

2.

You must first propound the theory and then explain the practice.

3.

Let no man who is not a mathematician read the principles of my work.

4.

In the course of scientific exposition the demonstration of a general rule derived from a previous conclusion is not to be censured.

{142}

[Sidenote: Certainty of Mathematics]

5.

He who blames the supreme certainty of mathematics feeds on confusion and will never be able to silence the contradictions or sophistical

sciences which lead to an everlasting clamour.

[Sidenote: Of Science]

6.

There is no certainty [in science] where one of the mathematical sciences cannot be applied, or in those [sciences] which are not in harmony with mathematics.

[Sidenote: From Leonardo's Dictionary]

7.

Syllogism: to speak doubtfully.

Sophism: to speak confusedly; falsehood for truth.

Theory: knowledge without practice.

[Sidenote: Definition of Science]

8.

Science is that discourse of the mind which derives its origin from

ultimate principles beyond which nothing in nature can be found which

forms a part of that science: as in the continued quantity, that is to

say, the science of geometry, which, starting from the surfaces of

bodies, has its origin in the line, which is the end of the

superficies; and we are not satisfied by this, because we know that the

line terminates in the point, and the point is that which is the least

of things. Therefore the point is the first principle of geometry, and

nothing else can exist either {143} in nature or in the human mind from

which the point can issue. Because if you say that the contact between

a surface and the extreme point of an iron instrument is the creation

of the point, it is not true; but let us say that this point of contact

is a superficies which surrounds its centre, and in the centre the

point dwells. And such a point is not a part of the substance of the

superficies, neither it nor all the points of the universe can, even if

combined,--it being granted that they could be combined,--compose any

part of a superficies. And granted, as you imagined, a whole composed

of a thousand points, if we divide any part of this quantity of a

thousand, we can very well say that this part shall equal its whole;

and this we can prove by zero, or naught, that is, the tenth figure of

arithmetic, which is represented by a cipher as being nothing, and

placed after unity it will signify 10, and if two ciphers are placed

after unity it will signify 100, and thus the number will go on

increasing by ten to infinity whenever a cipher is added, and the

cipher in itself is worth nothing more than naught, and all the naughts

in the universe are equal to one naught alone, in regard to their

substance and value.

9.

Knowledge which is the issue of experience is termed mechanical; that which is born and ends {144} in the mind is termed scientific; that which issues from science and ends in manual work is termed semi-mechanical. But I consider vain and full of error that science which is not the offspring of experience, mother of all certitude, and which does not result in established experience, that is to say, whose origin, middle and end do not pass through any of the five senses. And if we doubt of everything we perceive by the senses, should we not doubt much more of what is contrary to the senses, such as the existence of God and of the soul, and similar matters constantly under dispute and contention?

And it is truly the case that where reason is lacking it is supplemented by noise, which never happens in matters of certainty. On account of this we will say that where there is noise there is no true science, because truth has one end only, which, when it is made known, eternally silences controversy, and should controversy come to life again, it is lying and confused knowledge which is reborn, and not certainty. But true science is that which has penetrated into the senses through experience and silenced the tongue of the disputers, and which does not feed those who investigate it with dreams, but proceeds

from the basis of primary truths and established principles

successively and by true sequence to the end; as, for instance, what

comes under the heading of elementary mathematics, {145} that is,

numeration and measurement, termed arithmetic and geometry, which treat

with the highest truth of the discontinued and continued quantity.

Here there will be no dispute as to whether twice three make more or

less than six, nor whether two angles of a triangle are less than two

right angles, but eternal silence shall ignore all controversy, and the

devotees of the true science will finish their studies in peace, which

the lying mental sciences cannot do. And if thou sayest that true and

established science of this kind is a species of mechanics, because

they can only be completed by the hand, I will say the same of all the

arts, such as that which passes through the hand of the sculptor, which

is a kind of drawing, a part of painting; and astrology and the other

sciences pass through manual operation, but they are mental in the

first place, as painting, which first of all exists in the mind of the

composer, and cannot attain to fulfilment without manual labour. With

regard to painting, its true and scientific principles must be

established: what constitutes a shaded body, what constitutes a primary

shade, a derivative shade, what constitutes light: that is, darkness,

light, colour, size, shape, position, distance, propinquity, motion,

rest, which are comprehended by the mind only, and without manual

labour. And this is the science of painting which remains in the mind

of those who meditate on it, from which {146} issues the work in due

time, and is infinitely superior to the aforesaid contemplation or

science.

10.

Mechanics are the paradise of scientific mathematics, because with them we arrive at the fruits of mathematics.

11.

Experience is indispensable for the making of any instrument.

12.

Proportion is not only to be found in figures and measurements, but also in sound, weight, time and position, and in whatever power which exists.

13.

The power of the projecting force increases in proportion as the object projected is smaller; the acceleration of the motion increases to infinity proportionately to this diminution. It would follow that an atom would be almost as rapid as the imagination or the eye, which in a moment attains to the height of the stars, and consequently its voyage would be infinite, because the thing which can be infinitely diminished would have an infinite velocity and would travel on an infinite course (because every continuous quantity is divisible to infinity). And this opinion is {147} condemned by reason and consequently by experience.

Thus, you who observe rely not on authors who have merely by their imagination wished to be interpreters between nature and man, but on those alone who have applied their minds not to the hints of nature but to the results of their experience. And you must realize the deceptiveness of experiments; because those which often appear to be one and the same are often different, as is shown here.

[Sidenote: Effects correspond to the Force of their Cause]

14.

A spherical body which possesses a dense and resisting superficies will move as much in the rebound resulting from the resistance of a smooth and solid plane as it would if you threw it freely through the air, if the force applied be equal in both cases.

Oh, admirable justice of thine, thou first mover! thou hast not

permitted that any tone should fail to produce its necessary effects,

either as regards order or quantity. Seeing that a force impels an

object which it overcomes a distance of one hundred arms' length, and

if in obeying this law it meets with resistance, thou hast ordained

that the force of the shock will cause afresh a further movement, which

in its various bounds recuperates the whole sum of the distance it

should have travelled. And if you measure the distance {148}

accomplished by the aforesaid bounds you will find that they equal the

length of distance through which a similar object set in motion by an

equal force would travel freely through the air.

15.

Every action must be caused by motion.

16.

Motion is the cause of all life.

[Sidenote: Of Force]

17.

What is force? Force, I say, is a spiritual virtue, an invisible

power, which by accidental external violence is caused by motion, and

communicated and infused into bodies which are inert by nature, giving

them an active life of marvellous power.

18.

What is force? I say that force is a spiritual, incorporate and

invisible power, which for a brief duration is produced in bodies that

by accidental violence are displaced from their natural state of

inertia.

[Sidenote: Origin of Force]

19.

Force arises from dearth or abundance; it is the child of physical

motion and the grandchild of spiritual motion, and the mother and

origin of gravity. Gravity is confined to the elements of {149} water

and earth, and this force is infinite, because infinite worlds could be

moved by it if instruments could be made by which the force could be

generated. Force, with physical motion, and gravity, with resistance,

are the four accidental powers by which all mortal things live and die.

Force has its origin in spiritual motion, and this motion, flowing

through the limbs of sentient animals, enlarges their muscles, and thus

enlarged the muscles are shrunk in length and contract the tendons with which they are connected, and this is the cause of the strength in human limbs. The quality and quantity of the strength of a man can generate a further force, which will increase in proportion to the duration of the motions produced by them.

[Sidenote: Aspects of Force]

20.

Gravity, force and casual motion together with resistance are the four external powers by which all the visible actions of man live and die.

[Sidenote: Of Inertia]

21.

A motion tends to be continuous; a body set in motion continues to move as long as the impression of the motive power lasts in it.

[Sidenote: Can Man imitate a Bird's Flight?]

22.

The bird is an instrument which operates by mathematical laws, and man can reproduce all {150} the movements of this instrument, but cannot attain to the intensity of its power; and can only succeed in acquiring balance. Thus we will say that such an instrument constructed by man lacks only the soul of the bird, and the soul of man must counterfeit the soul of the bird. The spirit in the frame of the bird doubtless would respond to needs of that frame better than would the spirit of man, whose frame is different, more especially in the almost insensible motions of balance; and since we see the bird make provision for the many sensible varieties of movement, we can conclude by such experience that man can acquire knowledge of the more markedly sensible of these movements, and that he will be able to make ample provision against the destruction of that instrument of which he has made himself the spirit and the guide.

[Sidenote: Of Inertia]

23.

A natural and continuous motion seeks to preserve its course along the line of its starting-point, that is to say, let us call starting-point whatever place in which it varies.

24.

Everything maintains itself by motion. And if it were possible to describe a diameter of air on the sphere of the earth, like to a well, which would extend from one superficies to the other, {151} and if a weighty body were dropped into this well, the body would seek to remain stationary at the centre, but so strong would be the impetus that for many years it would prevent it from so doing.

[Sidenote: Transmission of Motion]

25.

Impetus is a virtue created by motion and communicated by the motive force to the object moved, and this object acquires motion in proportion to the energy of the impetus.

[Sidenote: Matter is Inert]

26.

No lifeless matter moves of itself, but its motion is caused from without.

27.

All elements displaced from their natural place seek to return to it, and more especially fire, water and earth.

28.

All matter universally seeks to maintain itself in its natural state; hence, water in motion seeks to maintain its course according to the force by which it is propelled, and if it meets with opposition it finishes the length of the course it began in a circular and reflex motion.

[Sidenote: Conception of Energy]

29.

Impetus is the impression of motion conveyed by the motive power to the object moved. Every {152} impression tends to permanence or seeks to attain permanence. That every impression seeks after permanence is proved by the impression made by the sun on the eye which regards it, and in the impression of sound made by the hammer which strikes a bell. Every impression seeks after permanence, as is shown in the image of impetus communicated to the object moved.

30.

A weight seeks to fall to the centre of the earth by the most direct way.

[Sidenote: In Praise of the Sun]

31.

If you look at the stars, warding off the rays (as may be done by looking through a small hole made by the extreme point of a fine needle placed so as almost to touch the eye), they will appear so small as to seem as though nothing could be smaller; it is owing to their great distance that they appear so small, for many of them are very many times larger than the star which is the earth with its water. Now reflect what appearance this our star must have from so great a distance, and then consider how many stars might be placed--both in longitude and latitude--between those stars which are sown in the dark space. I can never refrain from blaming many of the ancients who said that the size of the sun was no greater than {153} it appears; among whom was Epicurus. I believe he founded his reasoning on a light placed in our atmosphere equidistant from the centre of the earth, which, to any one looking at it, never appears to diminish in size from whatever distance it is seen.

32.

I shall reserve the reasons of its size and power for later. But I

greatly marvel that Socrates should have depreciated such a body, and

that he should have said that it resembled an incandescent stone; and

he who opposed him as regards this error acted rightly. But I wish I

had words to blame those who seek to exalt the worship of men more than

that of the sun, since in the universe there is no body of greater

magnitude and power to be seen than the sun. And its light illumines

all the celestial bodies which are distributed throughout the universe;

and the vital spark descends from it, because the heat which is in

living beings comes from the soul, and there is no other centre of heat

and light in the universe, as will be shown later; and it is certain

that those who have elected to worship men as gods--as Jupiter, Saturn,

Mars, &c.--have fallen into a profound error, since even if a man were

as great as our earth, he would have the appearance of a little star,

which appears like a dot in the universe; and moreover these men are

mortal, and decay and corrupt in their sepulchres.

{154}

33.

Epicurus perhaps saw the shadows of columns on the walls in front of

them equal to the diameter of the column which cast the shadow; and

since the breadth of the shadows are parallel from beginning to end he

considered that he might infer that the sun also was directly opposite

to this parallel, and consequently no broader than the column; and he did not perceive that the diminution of the shadow was insensibly small owing to the great distance of the sun. If the sun were smaller than the earth, the stars in a great portion of our hemisphere would be without light--in contradiction to Epicurus, who says the sun is only as large as it appears to be.

34.

Epicurus says the sun is the size it seems to be; hence, as it seems to be a foot in breadth, we must consider that to be its size. It follows that when the moon eclipses the sun, the sun ought not to appear the larger, as it does; hence, the moon being smaller than the sun, the moon must be less than a foot in breadth, and consequently when the earth eclipses the moon it must be less than a foot by a finger's breadth; inasmuch as if the sun is a foot in breadth, and the earth casts a conical shadow on the moon, it is inevitable that the luminous cause of the conical shadow {155} must be greater than the opaque body which causes it.

35.

Measure how many times the diameter of the sun will go into its course in twenty-four hours. And thus we can see whether Epicurus was correct in saying the sun was only as large as it appeared to be; for as the

apparent diameter of the sun is about a foot, and as the sun would go a thousand times into its course in twenty-four hours, it would have travelled a thousand feet, that is, three hundred arms' length, which is the sixth of a mile. Thus the course of the sun during twenty-four hours would have been the sixth part of a mile, and this venerable snail, the sun, would have travelled twenty-five arms' length in an hour.

[Sidenote: The Sun's Heat]

36.

They say that the sun is not hot because it is not the colour of fire but whiter and clearer. And the answer to this is that when molten bronze is hottest it resembles the colour of the sun, and when it is less hot it has the colour of fire.

37.

It is proved that the sun is by nature hot and not cold, as has already been stated. If rays of fire play on a concave mirror when it is cold, the rays refracted by the mirror will be hotter than {156} the fire. The rays emitted from a sphere of glass filled with cold water, which are reflected from a fire, will be warmer than the fire. It follows from these two experiments that the heat of the rays reflected by the

176

mirror or the sphere of cold water are hot by virtue, and not because

the mirror or the sphere is hot; and in this case it occurs that the

sun, passing through these bodies, heats them by its virtue. And owing

to this they have inferred that the sun is not hot,--which by the

aforesaid experiments has been proved to be exceedingly hot, by the

experiment of the mirror and the sphere, which are cold in themselves,

and reflect the hot rays of the fire and render them hotter, because

the first cause is hot; and the same thing occurs as regards the sun,

which, being hot in itself, and passing through these cold mirrors,

refracts great heat. It is not the light of the sun which gives

warmth, but its natural heat.

[Sidenote: Rays of the Sun]

38.

The rays of the sun pass through the cold region of the air without any

change being effected in their nature, they pass through glasses full

of cold water without suffering change; through whatever transparent

spot they pass, it is as though they passed through so much air.

[Sidenote: Light of the Stars]

39.

Some writers allege that the stars shine of {157} themselves, saying

that if Venus and Mercury did not shine of themselves, when their light

comes between them and the sun they would darken as much of the sun as

they could hide from our eye; this is false, because it is proved that

a dark body placed against a luminous body is enveloped and altogether

covered by the lateral rays of the remaining part of that body, and

thus remains invisible; as may be proved when the sun is seen through

the boughs of a leafless tree at a long distance, the boughs do not

hide any portion of the sun from our eyes. The same thing occurs with

the above-mentioned planets, which, though they have no light in

themselves, do not, as has been said, hide any portion of the sun from

our eyes.

Second proof. They say that the stars shine most brightly at night in

proportion as they are high; and that, if they did not shine of

themselves, the shadow cast by the earth between them and the sun would

darken them, since they would not see nor be seen by the sun. But

these have not taken into consideration that the conical shadow of the

moon does not reach many of the stars, and even for those it does reach

the shadow is diminished to such an extent that it covers very little

of the star, and the remaining part is illumined by the sun.

{158}

[Sidenote: On the Nature of the Moon]

40.

The moon having density and gravity, how does it stand?

41.

i. No very light object is opaque.

ii. Nothing light can remain beneath that which is heavier.

iii. Whether the moon is the centre of its elements or not. And if it has no fixed position like the earth in the centre of its elements, why does it not fall to the centre of our elements? And if the moon is not in the centre of its elements and does not fall, it must then be lighter than any other element. And if the moon is lighter than the other elements, why is it opaque and not transparent?

42.

No body which has density is lighter than the air. Having proved that the part of the moon which shines consists of water which mirrors the body of the sun and reflects for us the splendour it receives from the sun, and that if there were no waves in these waters, it would appear small, but almost as bright as the sun--it must now be shown whether the moon is a heavy or a light body; if it is a heavy body--admitting

that from the earth upwards with every grade of distance lightness must

increase, so that water is lighter than earth, air is lighter than

water, and {159} fire lighter than air, and so on in succession--it

would seem that if the moon had density, as it has, it must have

gravity, and if it has gravity the space in which it lies could not

contain it, and consequently it would fall towards the centre of the

universe and be joined to the earth, or if not the moon itself, its

waters would fall from the moon and strip it and fall towards the

centre, leaving the moon bare and lustreless; whence, as this could not

happen, as reason would tell us, it is manifest that the moon is

surrounded by its elements, that is to say, water, air and fire, and

thus it sustains itself by itself in that space as our earth is

suspended with its elements in this part of space; heavy bodies act in

their elements there just as other heavy bodies act in ours.

[Sidenote: On the Harmony of the Spheres]

43.

A sound is produced by the movement of the air in friction against a

dense body, and should it be produced by two weighty bodies it is owing

to the atmosphere which surrounds them, and this friction consumes the

bodies, so that it follows that the spheres in their friction, owing to

there being no atmosphere between them, do not generate sound. And if

this friction were a fact, during the many centuries the spheres have

revolved they would be consumed by the immense velocity expended daily;

and even if they produce sound, the sound could not travel, {160}

because the sound caused by percussion under water is scarcely

noticeable, and it would be less than noticeable in the case of dense

bodies. The friction of polished bodies produces no sound, and similar

result would be produced in the contact or friction of the spheres; and

if the spheres are not polished in their contact and friction, it

follows that they are rough.

Again, their contact is not continuous; this being the case a vacuum is

produced, which it has been proved does not exist in nature. Therefore

we conclude that friction would have consumed the ends of each sphere,

and in proportion as a sphere has a greater velocity in the centre than

at the poles, it would be consumed to a higher degree at the centre

than at the poles; and then the friction would cease, and the sound

would cease also, and the spheres would cease to revolve unless one

sphere revolved eastward and the other northward.

44.

Worlds gravitate in the midst of their own elements. The yellow or

yolk of an egg remains in the middle of the albumen without moving on

either side, and is lighter or heavier or equal to this albumen; and if

it is lighter it ought to rise above all the albumen and stop in

contact with the shell of the egg; and if it is heavier it ought {161}

to sink; and if it is equal to it, it can stand at one of the ends as

well as in the centre or below.

[Sidenote: The Earth appears a Star]

45.

The object of my book is to prove that the ocean, with the other seas, by means of the sun causes our world to shine like the moon and to appear as a star to other worlds; and this I will prove.

[Sidenote: The Earth a Star]

46.

In your discourse you must prove that the earth is a star like the moon, and thus you will bear witness to the glory of our universe! And thus you must discourse on the size of many stars.

47.

How the earth is a star. The earth, in the midst of the sphere of water which clothes the greater part of it, taking its light from the sun and shining in the universe like the other stars, shows itself to be a star as well.

48.

First of all define the eye; then show how the twinkling of a star
exists really in the eye, and why one star should twinkle more than
another, and how the rays of the stars are born in the eye. Say, that
if the twinkling of the stars were, as it appears to be, really in the
stars, that this {162} twinkling appears to extend in proportion to the
body of the star. The star, therefore, being larger than the earth,
this motion made in an instant of time would in its velocity double the
size of the star. Then prove that the surface of the atmosphere,
contiguous to fire and the surface of fire, where it ends, is the point
in which the rays of the sun penetrate and bear the image of the
celestial bodies which are large when they rise and set, and small when
they are on the meridian.

[Sidenote: Earth not the Center of Universe]

49.

The earth is not the centre of the orbit of the sun, nor the centre of
the universe, but in the centre of its companion elements and united
with them; and if any one were to stand on the moon when the moon and
the sun are beneath us, our earth, with its element of water, would

appear and shine for him just as the moon appears and shines for us.

50.

The earth, shining like the moon, has lost a great part of its ancient splendour by the decrease of the waters.

51.

Nothing is generated in a place where is no sentient vegetable and rational life; feathers grow on birds and change every year; coats grow on animals and are changed every year, with some {163} exceptions, like the lion's beard and the cat's fur, and such; grass grows in the fields and leaves on the trees; and every year they are renewed in great part. Thus we can say that the spirit of growth is the soul of the earth, the soil its flesh, the ordered arrangement of rocks its bones, of which mountains are formed, the tufa its tendons; its blood the veins of water which surround its heart, which is the ocean; its breathing and increase and decrease of blood in the pulses the ebb and flood of the sea; and the heat of the spirit of the world is fire which pervades the earth, and the vital soul dwells in the fires which from various apertures of the earth issue in springs and sulphur minerals and volcanoes, as at Mount Etna in Sicily and in many other places.

52.

The ancients called man the world in miniature, and certainly the name
is a happy one, because man being composed of earth, water, air and
fire, the body of the earth resembles the body of man. As man has in
him bones for the support and framework of his flesh, likewise in the
world the rocks are the supports of the earth; as man has in him a pool
of blood in which the lungs rise and fall in their breathing, so the
body of the earth has its ocean which rises and falls every six hours
as if the world breathed; as from the aforesaid pool of blood veins
issue which {164} ramify throughout the human body, so does the ocean
fill the body of the earth with innumerable veins of water. The body
of the earth lacks sinews, which do not exist because sinews are made
for movement, and the world being in perpetual stability no movement
occurs, and there being no movement, sinews are not necessary; but in
all other points they resemble each other greatly.

53.

Water is the driver of nature.

[Sidenote: Experience the Basis of Science]

54.

185

In explaining the action of water remember to cite experience first and then reason.

55.

Do not forget that you must put forward propositions adducing the above-mentioned facts as illustrations, not as propositions,--that would be too simple.

56.

Water in itself has no stability and cannot move of its own accord, save to descend. Water of its own accord does not cease to move unless it is shut in.

57.

The body of the earth, like the body of animals, is intersected with ramifying veins, which are all {165} united and constructed for the nourishment and life of the earth and of its creatures.

[Sidenote: Water is the Blood of the World]

58.

The water which rises in the mountains is the blood which keeps the mountain alive, and through this conduit or vein, nature, the helper of her creatures, prompt in the desire to repair the loss of the moisture expended, proffers the desired aid abundantly; just as in a stricken spot in man you will see, owing to the aid which is brought, the blood abound under the skin in a swelling, so as to succour the spot which has been stricken; likewise, in the case of the vine, when it is cut at its extremity, nature causes its moisture to rise from the lowest root to the end of the extremity which has been cut, and when this moisture has been expended nature ceases not to supply it with vital moisture to the end of its life.

59.

Water is that which is given to supply vital moisture to this arid earth; and the cause which propels it through its ramifications against the natural course of weighty matter is the same which stirs the humours in every kind of animal body.

[Sidenote: Water on Mountains]

60.

187

Water, the vital moisture of the earthly machine, moves by reason of its natural heat.

{166}

[Sidenote: On the Water of Rivers]

61.

Rivers, with their ruinous inundations, seem to me the most potent of all causes of terrestrial losses, and not fire, as some have maintained; because the violence of fire is exhausted where there is nothing forthcoming to feed it. The flowing of water, which is maintained by sloping valleys, ends and dies at the lowest depth of the valley; but fire is caused by fuel and the movement of water by incline. The fuel of fire is disunited, and its damage is disunited and isolated, and fire dies where there is no fuel. The incline of valleys is united, and damage caused by water is collective, along with the ruinous course of the river, until with its valley it winds into the sea, the universal base and sole haven of the wandering waters of rivers. But what voice or words shall I find to express the disastrous ravages, the incredible upheavals, the insatiable rapacity, caused by the headstrong rivers? What can I say? Certainly I do not feel myself equal to such a demonstration, yet by experience I will try to relate the process of ruin of the rivers which destroy their banks and against

which no mortal bastion can prevail.

62.

The recesses of the bottom of the sea are perennial, the summits of
mountains are transitory, whence it follows that the earth will become
{167} spherical and covered with waters, and will be uninhabitable.

[Sidenote: Transformations in Past and Future]

63.

The shores of the sea continually increase in soil, towards the middle
of the sea; the cliffs and promontories of the sea are continually
being ruined and consumed; the mediterranean seas will dry up and all
that will remain will be the channel of the greatest river which enters
into them; this will flow to the ocean and pour out its waters together
with that of all the rivers which are its tributaries.

[Sidenote: On the Earth's Vibration]

64.

The subterranean courses of water, like those which are made between

the air and the earth, are those which continually consume and deepen the beds of their currents. The earth which is carried by rivers is discharged at the end of their course, that is to say, the earth carried from the highest part of the river's course is discharged at the lowest depth of its course. Where fresh water arises in the sea, the miracle of the creation of an island is manifest, which will be discovered sooner or later in proportion as the quantity of water is greater or less. And an island of this kind is formed by the deposit of earth and stones made by the subterranean current of water in the channels through which it passes.

{168}

[Sidenote: Nature's Law]

65.

Nature never breaks her laws.

66.

Nature is constrained by the cause of her laws which dwells inborn in her.

67.

Without reason no effect is produced in nature; understand the reason and you will not need experience.

[Sidenote: Cause discovered by Effect]

68.

Before I proceed further I will make some experiments, because it is my intention to cite the experiment first and then to demonstrate by reasoning how such an experiment must necessarily take effect in such a manner. And this is the true rule by which investigations of natural phenomena must proceed; and although nature herself begins from the reason and ends in the result, we must pursue the contrary course and begin, as I said above, from experience and by it seek out the reason.

[Sidenote: Repetition of Experiment]

69.

Before deducing a general rule from this case repeat the experiment two or three times and see if the same results are produced.

{169}

70.

It several bodies of equal weight and shape are dropped one after another at equal intervals of time, the distances between each successive body will be equally increased.

The experiment to prove the above-mentioned theorem respecting motion must be made thus: Take two balls of equal weight and shape and let them fall from a great height so that when they start falling they touch one another, and let the investigator stand on the ground and watch whether the contact is maintained during their fall. This experiment must be repeated several times, so that the trial may not be marred by any accident and the experiment vitiated and the spectator deceived.

71.

We know definitely that sight is infinitely swift and in an instant of time perceives countless shapes, nevertheless it only sees one object at a time. Let us take an example. You, O reader, will see the whole of this written page at a glance, and you will instantly realize that

it is full of various letters, but you will not realize at that moment what these letters are nor what they signify; wherefore you will have to proceed word by word and line by line to take cognizance of these letters. Again, if you wish to reach the summit of a building you must mount step by step, {170} otherwise it will be impossible for you to reach the summit. And therefore I say to you whom nature has drawn to this art, if you wish to attain to a thorough knowledge of the forms of objects, you will begin by studying the details, and not proceed to the second until you have committed the first to memory and mastered it in practice, and if you do otherwise you will be wasting your time and protracting your studies. And remember first of all to acquire diligence, which signifies speed.

[Sidenote: Vision]

72.

Of the nature of the eye. Here are the forms, here the colours, here the form of every part of the universe are concentrated in a point, and that point is so great a marvel! O marvellous and stupendous necessity! thou dost compel by thy law, and by the most direct path, every effect to proceed from its cause. These things are verily miracles! I wrote in my Anatomy how in so small a space the visual faculty can be reproduced and formed again in its whole expanse.

73.

In many cases one and the same thing is attracted by two violent

forces,--necessity and power. The water falls in rain and by necessity

the earth absorbs the humidity; the sun causes it to evaporate, not of

necessity, but by power.

{171}

[Sidenote: Unconscious Reasoning]

74.

The pupil of the eye in the air expands and contracts according to

every degree of motion made by the sun. And with every dilation or

contraction the same object will appear of a different size, although

frequently the relative scale of surrounding circumstances does not

allow us to perceive these variations in any single object we look at.

[Sidenote: The Eye]

75.

The pupil of the eye dilates and contracts in proportion to the variety

of bright and dark objects which are reflected in it. In this case

nature has afforded compensation to the visual faculty by contracting

the pupil of the eye when it is offended by excess of light and by causing it to dilate when offended by excess of darkness, like the opening of the purse. And nature here behaves like the man who has too much light in his house and closes half the window, or more or less of it according to need; and when night comes he opens the window altogether so as to see better inside his house, and nature here adopts a continued process of compensation, by continually regulating and readjusting the expansion and contracting of the pupil, in proportion to the aforesaid obscurity and light which are continually reflected in it.

{172}

[Sidenote: Water surrounding the Globe Spherical]

76.

When you collect facts relating to the science of the motion of water, remember to place under every proposition the uses to which it may be applied, in order that this knowledge may not be fruitless.

77.

This is a difficult question to answer, but I will nevertheless state my opinion. Water, which is clothed with air, desires naturally to

cleave to its sphere because in this position it is without gravity.
This gravity is twofold,--the gravity of the whole which tends to the
centre of the elements, and the gravity which tends to the centre of
the waters of the spherical orb; if this were not so the water would
form a half sphere only, which is the sphere described from the centre
upwards. But I see no means in the human mind of acquiring knowledge
with regard to this. We must say, as we say of the magnet which
attracts iron, that such a virtue is an occult property of which there
is an infinite quantity in nature.

78.

In the motion of earth against earth the repercussion of the portion
struck is slight.

Water struck by water, eddies in circles around the spot where the
shock has taken place.

The reverberation of the voice continues for a {173} great distance
through the air; for a greater distance through fire. The mind travels
for a still greater distance through the universe; but since it is
finite it does not penetrate into infinity.

79.

If the water which rises on the summits of the mountains comes from the

sea, whence it is propelled by its weight to a greater height than that

of the mountains, why has this portion of the element of water the

power to elevate itself to such an altitude and to penetrate the earth

by so great an expenditure of labour and time, when the residue of the

element of water, whose only obstacle is the air which does not impede

it, is not able to raise itself to a similar altitude? And thou who

didst devise this theory, go and study nature, so that thou mayst cease

to acquire such opinions of which thou hast made so great a collection,

together with the capital and interest which thou dost possess.

[Sidenote: On the Law of Gravity]

80.

The sphere of the earth has gravity which increases in proportion to

the lightness of the element which contains it.

Fire is light in its sphere and its lightness increases in proportion

to the weight of the element which contains it.

{174}

No primary element has gravity or lightness in its own sphere.

81.

The motion made by bodies which possess gravity to the common centre is not produced by the tendency of the body to find this centre, nor is it caused by attraction made by the centre, as by a magnet, drawing the weight towards it.

82.

Why does not the weight remain in its place?

It does not remain because it has no resistance.

And whither will it tend?

It will tend to the centre of the earth.

And why not along other lines?

Because the weight which meets with no resistance will descend by the shortest way to the lowest depth, and the lowest depth is the centre of the earth.

And how does a weight find the centre of the earth with such directness?

Because it does not proceed at random, wandering by diverse courses.

83.

Instrumental science, that is to say, mechanics, is the most noble and most useful of sciences, inasmuch as by means of it all living bodies which have movement act; and this movement has {175} its origin in the centre of gravity which is placed in the middle, dividing unequal weights, and it has dearth and wealth of muscles and lever also and counter-lever.

84.

Since these things are far more ancient than letters, it is no wonder if in our day no records exist to tell how these seas filled so many countries. But if some record had existed, conflagrations, floods, wars, changes of tongues and laws have consumed all that is ancient; sufficient for us is the testimony of objects born in the salt waters and found again in the high mountains far off from the seas of those times.

[Sidenote: Heat the Vital Principle]

85.

Heat causes moisture to move, and cold arrests it; as is seen in a cold country which arrests the motion of the clouds in the air. Where there is life there is heat, where there is vital heat there is movement of moisture.

[Sidenote: Against those desiring to correct Nature]

86.

The act of cutting out the nostrils of a horse is a piece of ludicrous folly. And the foolish indulge in this practice as though they considered nature had failed to supply necessary wants, and man had therefore to supplement her work. Nature made two apertures in the nose, which each in {176} itself is half as large as the lung pipe whence breath proceeds, and if these apertures did not exist the mouth would abundantly suffice for breathing purposes. And if you said to me, Why has nature thus provided animals with nostrils if respiration through the mouth is sufficient?--I would answer that nostrils are made to be used when the mouth is employed in masticating its food.

[Sidenote: Of Trees]

87.

If a tree has been stripped of its bark in some spot, nature makes provision for this and gives a greater supply of nourishing sap to the stripped portion than to any other, so that in place of what has been taken away the bark grows thicker than in any other spot. And so impetuous is the motion of the sap that when it reaches the spot which is to be healed, it rises higher like a bounding ball, in bubbles, not unlike boiling water.

[Sidenote: The Leaves of Plants]

88.

Nature has so placed the leaves of the latest shoots of many trees that the sixth leaf is always above the first, and thus in continued succession unless the rule is obstructed. And this she has done for two useful purposes in the plant: firstly, since the branches and the fruit of the following year spring from the bud or eye which is above and in contact with the juncture of the leaves, {177} the water which feeds the shoot may be able to run down and nourish the bud, through the drop being caught in the hollow whence the leaf springs. And the second advantage is that as these buds shoot in the following year, one will not be covered by the other, since the five shoots spring on five different sides.

89.

In order to arrive at knowledge of the motions of birds in the air, it is first necessary to acquire knowledge of the winds, which we will prove by the motions of water in itself, and this knowledge will be a step enabling us to arrive at the knowledge of beings that fly between the air and the wind.

90.

The reason of this is that small birds being without down cannot support the intense cold of the high altitudes in which the vultures and eagles or and other great birds, well supplied with down and clothed with many kinds of feathers, [fly]. Again, the small birds, having delicate and thin wings, support themselves in the low air, which is denser, and they could not bear up in the rarer air, which affords slighter resistance.

91.

The shafts formed in the shoulders of the wings of birds have been so devised by ingenious nature {178} as to occasion a convenient pliancy in the direct impetus which often occurs in the swift flight of birds, since she found it more practical to bend a small part of the wing in the direct flight than the whole of it.

[Sidenote: On a Fossil Fish]

92.

O time! swift devourer of all created things! How many kings, how many nations, thou hast overthrown, how great changes of kingdoms and diverse vicissitudes have succeeded one another, since the marvellous body of this fish, which perished in the caverns and intricate recesses [of the mountain]. Now undone by time, thou liest patient in this confined spot; with thy fleshless and bare bones thou hast built the framework and the support of the mountain that is above thee.

[Sidenote: We live by Others' Death]

93.

Unconscious life remains in what is dead, which when reunited to the stomach of living men, reacquires sentient and conscious life.

[Sidenote: Against Doctors]

94.

Men are chosen to be physicians in order to minister to diseases of which they are ignorant.

95.

Every man wishes to amass money in order to give it to the physicians who are the destroyers of life; they ought therefore to be rich.

{179}

96.

Take pains to preserve thy health; and thou wilt all the more easily do this if thou avoidest physicians, because their drugs are a kind of alchemy, and there are as many books on this subject as there are on medicine.

97.

Oh! meditators on perpetual motion, how many vain projects of similar character you have devised! Go and join the seekers of gold.

[Sidenote: Against the Seekers of Perpetual Motion]

98.

The water which flows in a river moves either because it is summoned or driven, or because it moves of its own accord. If it is summoned,--and I mean sought after,--who is the seeker? If it is driven, who is the driver? If it moves of its own accord, it gives evidence of reasoning; and reasoning in bodies which continually change their shape is impossible, because in such bodies there is no consciousness.

[Sidenote: Against Occult Sciences]

99.

I wish to work miracles. I may have less than other and less energetic men; and those who wish to grow rich in a day live a long time in great poverty, as happens, and will always happen, to alchemists, who seek to make gold and silver, and to the engineers who wish from still {180} water to obtain life and perpetual motion, and to the supreme fool,--the necromancer and the magician.

100.

There is no part of astronomy which does not depend on the visual lines and on perspective, the daughter of painting; because the painter is he who by the necessity of his art has begotten perspective, and it is impossible to do without lines which include all the various figures of the bodies begotten by nature and without which the art of geometry is blind. And while the geometrist reduces every surface surrounded by lines to a square, and each body to the figure of the cube, and mathematics do the same with their cube roots and square roots, these two sciences deal only with the continuous and discontinuous quantity, but they do not deal with the quality which constitutes the beauty of the works of nature and the ornament of the world.

101.

Here the adversary will say that he does not want so much knowledge, and the mere skill of depicting nature will suffice him. To which I make reply that there is no greater error than to trust to our judgement without other reasoning, as experience, the enemy of alchemists, necromancers and other foolish intellects, has in all times proved.

{181}

[Sidenote: Against Alchemists]

102.

The lying interpreters of nature affirm that quicksilver is the common seed of all metals. They do not bear in mind that nature raises substances according to the diversity of things which she wishes to produce in the world.

[Sidenote: Against Necromancy]

103.

The belief in necromancy is reputed to be the most foolish of all human opinions. It is the sister of alchemy which gives birth to simple and natural things; but it is all the more reprehensible than alchemy, inasmuch as it brings forth nothing but what is like itself, that is, lies. This is not the case with alchemy, which is confined to the simple products of nature, and whose function cannot be performed by nature herself, because in it there are no organic instruments with which it can work, such as the hands are to man and which have enabled him to make glass, &c. But necromancy, the flag and flying banner, blown hither and thither by the winds, is the guide of the silly

multitude, which constantly bears witness with gaping wonder to the

countless effects of this art; and whole books are written which

declare that incantations and spirits are efficacious and speak without

tongues and without vocal organs, without which it is impossible to

speak, and carry the heaviest weights, raising tempests and rain and

{182} transforming men into cats, wolves and other beasts, although

they who affirm such things are the first to be transformed into

beasts. And certainly if such necromancy existed, as is believed by

lower intellects, there is nothing on the earth which would be so

effectual both as regards the service and detriment of man; because if

it is true that this art has the power to disturb the calm serenity of

the atmosphere, changing it into night and producing sparks and winds,

with fearful thunder and lightnings that fly through the darkness, and

overthrowing high buildings with violent winds and uprooting forests

and striking armies and shattering and overwhelming them, and

producing, in addition to this, devastating storms which rob the

peasants of the fruits of their toil, what kind of warfare is there so

deadly to the enemy? Who in naval warfare can be compared with him who

commands the winds and generates storms which ruin and sink any fleet

whatsoever? Certainly he who could dispose of such violent forces

would be the lord of nations, and no human skill could resist his

deadly power. The hidden treasures and gems concealed in the body of

the earth would be manifest unto him. He would let himself be borne

through the air from the east to the west, and through all the opposed

regions of the universe. But why should I proceed further? What thing

is there which could not be effected by such an art? Nothing, save

{183} the discovery of immortality. And if it is true, why has it not

remained among men who so greatly desired it, and led them to disregard any deity? And I know that there are many who to satisfy a whim would destroy God and the universe. And if necromancy has not remained with man in spite of its being so necessary to him it can never have existed, nor will it ever exist according to the definition of the spirit which is invisible in the body, for in the elements there are no incorporate things, for where there is no body there is a vacuum, and a vacuum cannot exist in the elements because it would be immediately filled by them.

[Sidenote: Deceptiveness of the Senses]

104.

The eye in its given distances and by its given means deceives itself in the performance of its functions less than any other sense, because it sees in straight lines which form a cone, the base of which is the object it perceives, and transmits it to the eye, as I intend to prove. But the ear greatly deceives itself as to the position and distance of the objects it apprehends, because the sonorous waves do not reach it in straight lines, like those of the eye, but by tortuous and reflex lines, and often the most remote seem to be nearest, owing to the peregrinations of such waves, although the voice of the echo is transmitted to the sense by straight lines only. The smell is less certain of the spot whence the odour arises, but {184} taste and touch alone come into direct contact with the object which they apprehend.

[Sidenote: On the Conception of Nothingness]

105.

The smallest natural point is larger than all mathematical points, and the proof of this is that the natural point has continuity, and everything which has continuity is infinitely divisible; but the mathematical point is indivisible because it is not a quantity. Every continuous quantity is mentally infinitely divisible. Among the magnitude of things which are among us, the chief of all is nothingness; and its function extends to matter that does not exist, and its essence is in time in the past or in the future, and it has nothing of the present. This nothingness has its part equal to the whole and the whole to the part, and the divisible to the indivisible, and produces the same result by addition or subtraction, or if it be divided or multiplied,--as is proved by arithmeticians by their tenth character, which represents nothing. And its power does not extend to the things of nature.

That which is called nothingness is found only in time and in words: in time it is found in the past and future, and not in the present; and thus in words among things which are said to be nonexistent or impossible. In time nothingness dwells in the past and the future, and not at all in the present, and in nature it resides among the things {185} which are impossible. Whence from that which has been said, it

has no being, because where there is nothingness there would be a vacuum.

[Sidenote: On Spirits]

106.

With regard to this matter, we have said on the previous page that the definition of a spirit is a power united with a body, because it cannot move of its own accord nor acquire any kind of motion. And if you say that it moves itself, this cannot be within the elements, because if the spirit is an incorporate quantity this quantity is a vacuum and the vacuum does not exist in nature, and if it did exist it would be immediately filled by the rushing in of the element in which the vacuum was formed. So according to the definition of weight which runs: "Gravity is an accidental power created by one element attracted to or suspended in another," it follows that no element, weighing nothing in its own element, can have weight in the element which is above it and lighter than it; for instance, no one part of water has no more gravity or lightness than any other part, but if you were to draw it up into the air, it would acquire weight, and this weight cannot sustain itself by itself; and it must therefore inevitably fall, and thus wherever there is a vacuum in water it will fall in. The same thing would happen with a spirit among the elements where it would continuously generate a vacuum {186} in whatever element it might find itself, for which reason it is inevitable that it would move in a constant flight

211

to the sky until it had quitted these elements.

[Sidenote: Has the Spirit a Body?]

107.

We have proved that a spirit cannot exist in the elements without a
body, nor move of itself by voluntary motion unless it be to rise
upwards. But now we will say that if such a spirit took a body made of
air it would inevitably melt into air, because if it remained united it
would be separated and fall and form a vacuum, as we have described
above. Therefore if it desired to remain in the air it is necessary
that it should blend with a quantity of air, and if it were united with
the air, two difficulties arise: that is, that it will rarefy that
portion of air with which it is mingled, and this rarefied air will fly
upwards and will not remain in the air which is heavier than itself;
and besides this the ethereal spiritual essence is disunited, and its
nature is changed, for which reason that nature loses some of its first
virtue. There is in addition to these a third difficulty, and this is
that a body of this kind, made of air and assumed by the spirits, is
exposed to the penetrating winds which continually sunder and scatter
the united portions of the air, eddying and whirling amidst the rest of
the atmosphere; therefore the spirit who would pervade {187} this air
would be dismembered or rent and broken up with the rending of the air
of which it formed part.

108.

It is impossible that the spirit, incorporated with a certain quantity
of air, should move this air; and this is proved by the passage where
it is said that "the spirit rarefies that portion of the air with which
it is mingled." This air therefore will rise high above the other air,
and the air will be set in motion by its own lightness and not by the
volition of the spirit, and if this air encounters a wind, the air will
be moved by the wind and not by the spirit which is incorporated in it.

[Sidenote: Can the Spirit speak?]

109.

In order to show whether the spirit can speak or not it is first
necessary to define the voice and the manner of its origin. The
following will be our definition: The voice is the movement of air in
friction against a dense body, or a dense body in friction against the
air (which is the same idea), and by this friction of the dense and the
rare what is rare is condensed, and resistance is caused; and again,
when the rare in swift motion and the rare in slow motion come into
contact, they condense one another and produce sound, and a great noise
is made. The sound or murmur made by the rare moving through the rare
{188} with slow motion is like the great flame whence sounds issue in
the air; the exceedingly great noise made by the rare, when the air

213

which is rare and swift mingles with that which is rare and in [slow]

motion, is like the flame of fire issuing from a great gun and striking

against the air; likewise the flame when it issues from a cloud strikes

the air as it begets the thunderbolt. Therefore we will say that the

spirit cannot produce a voice unless the air be set in motion, but

since there is no air within, it cannot discharge what it does not

possess; and if it wishes to move that air in which it is incorporated,

it is necessary that the spirit should multiply itself; but that which

has no quantity cannot be multiplied. In the fourth place it is said,

that no rare body can move if it has not a stable spot whence it may

take its motion, and more especially is this the case when an element

must move in its own element, which does not move of itself, excepting

by uniform evaporation at the centre of the thing evaporated; as occurs

in the case of the sponge squeezed in the hand under water, whence the

water escapes in every direction with equal motion through the spaces

between the fingers of the hand which squeezes it. As to whether the

spirit has an articulate voice and can be heard, and as to what are

hearing and sight--the wave of the voice travels through the air as the

images of objects travel to the eye.

{189}

110.

O mathematicians, clear up this error! The spirit cannot have a voice,

for where there is a voice there is a body, and where there is a body

there is occupation of space, which prevents the eye seeing what is

214

behind that space; therefore a body fills all the surrounding air, that is to say, with its own image.

111.

There can be no voice where there is no motion or percussion of the air, there can be no percussion of the air where there is no instrument, there can be no such thing as an immaterial instrument; and this being so, a spirit can have neither voice, nor shape, nor force; and if it assumes a shape it can neither penetrate nor enter where the issues are closed. If any one were to say that a spirit may take bodies of various shapes by means of concentrated and compressed air, and by means of this instrument speak and move with force--I reply to this argument that where there are no nerves or bones, no force can be expended in any movement made by these imaginary spirits.

{193}

BIBLIOGRAPHICAL NOTE

AND

TABLE OF REFERENCES

BIBLIOGRAPHICAL NOTE

* *

*

Only of late years have the manuscripts of Leonardo da Vinci seen the light and the many difficulties been overcome which long proved an obstacle to their publication. The labour of editing, deciphering and translating his many scattered and fragmentary codices was beyond the efforts of any single man. The gratitude of the cultivated world is therefore due to those who, like J. P. Richter, C. Kavaisson-Mollien, Luca Beltrami, Piumati, Sabachnikoff, and, last but not least, the scholars of the Academia del Lincei, have so faithfully devoted themselves to this task, which alone has made possible the present little work.

It was unavoidable that the form in which these manuscripts have been published should practically restrict their possession to the great libraries. But an excellent volume of selections from the writings of Leonardo, which are found in so haphazard a manner scattered through his codices and intermingled with his drawings and diagrams, has been published in Italy (Leonardo da Vinci: Frammenti Letterari e Storici, Florence, 1900). By kind permission of its editor, Dr. Solmi, this has served as a basis for the text of the present translation. The references, however, have {194} been verified with the complete

editions of Leonardo's works, while a different arrangement has been made of the text.

L. E.

[Sidenote: Table of References]

TABLE OF REFERENCES

[A] Les manuscrits de Léonard de Vinci. Le manuscrit A de la Bibliothèque de l'Institut. Edit. Ravaisson-Mollien, vol. i. Paris, 1880.

[ASH I] Les manuscrits de Léonard de Vinci. Les manuscrits H de la Bibliothèque de l'Institut; 2038 (Ash I) et 2037 (Ash II) de la Bibliotheque Nationale. Edit. Ravaisson-Mollien, vol. vi. Paris, 1891.

[ASH II] Idem.

[B] Les manuscrits de Léonard de Vinci. Les manuscrits B et D de la Bibliothèque de l'Institut. Edit. Ravaisson-Mollien, vol. ii. Paris, 1883.

[C] Les manuscrits de Leonard de Vinci. Les manuscrits C, E et K de la

Bibliothèque de l'Institut. Edit. Ravaisson-Mollien, vol. iii.
Paris, 1888.

[C A] Il Codice Atlantico di Léonardo da Vinci nella Biblioteca
Ambrosiana di Milano. Rome; Milan, 1891. (Still in course of
publication.)

[D] See B.

[E] See C.

[F] Les manuscrits de Léonard de Vinci. Les manuscrits F et I de la
Bibliothèque de l'Institut. Edit. Ravaisson-Mollien, vol. iv. Paris,
1889.

{195}

[G] Les manuscrits de Léonard de Vinci. Les manuscrits G, L et M de la
Bibliothèque de l'Institut. Edit. Ravaisson-Mollien, vol. v. Paris,
1890.

[H] See Ash I.

[I] See F.

[L] See G.

[Lu] Léonardo da Vinci: Das Buch vom Malerei. Herausgegeben v. H. Ludwig. 3 vols. Berlin, 1882.

[M] See G.

[R] The Literary Works of Leonardo da Vinci. Compiled and edited from the original manuscripts by J. P. Richter. 2 vols. London, 1883.

[S] Leonardo da Vinci: Frammenti Letterari e Filosofici. Trasceiti dal Dr. Edmondo Solmi. Florence, 1900.

[T] Il codice di Léonardo da Vinci nella Biblioteca del Principe Trivulzio. Edit. L. Beltrami. Milan, 1892.

[V U] Leonardo da Vinci. Il codice del volo degli uccelli ed altre materie. Edit. Sabachnikoff e Piumati. Paris, 1893.

[Sidenote: On Life]

THOUGHTS ON LIFE

Page. No. Reference. Page. No. Reference.

Page	No.	Reference	Page	No.	Reference
3	1	R 4	4	4	CA 119 r
3	2	R 1339	5	5	Lu 9

4 3 R 841 5 6 R 1169

{196}

12	28	C A 76 r	21	57	T 6 r
12	29	F 27 v	21	58	G 74 v
12	30	S 83	22	58	S 121
12	31	R 1150	22	60	S 122
12	32	C A 154 r	22	61	S 123
13	33	C A 154 r	23	62	H 89 v
13	34	C A 86 r	23	63	S 168
13	35	T 20 v	23	64	F 49 v

{197}

{198}

[Sidenote: On Art]

59	1	C A 141 v	85	24	Lu 29
60	2	S 274	85	25	Lu 31
60	3	Lu 438	87	26	Lu 30
60	4	Lu 27	88	27	Lu 32
60	5	Lu 34	90	28	S 276
61	6	Lu 7	90	29	Lu 9
62	7	Lu 8	90	30	Lu 13
64	8	Ash II 19 v	91	31	S 275
65	9	Lu 2	92	32	Ash II 20 r
66	10	Lu 7	92	33	Ash II 26 r
66	11	Lu 14	93	34	Ash II 25 r 24 v
68	12	Lu 10			
68	13	Lu 46	95	35	Lu 35
68	14	Lu 18	96	36	Lu 36
69	15	Lu 20	97	37	Lu 38
71	16	Lu 21	98	38	Lu 40
72	17	Lu 22	99	39	Lu 41
73	18	S 251	100	40	Lu 405
77	19	S 257	100	41	Lu 62
80	20	Lu 27	100	42	R 498
82	21	Lu 27	100	43	Lu 57
82	22	Lu 26	101	44	Ash II 16 v
83	23	Lu 28	101	45	Lu 58

116	69	S 122		137	93	S 340

[Sidenote: On Science]

THOUGHTS ON SCIENCE

141	1	Lu 1		141	3	R 3
141	2	R 110		141	4	R 6

{200}

Page.	No.	Reference.	Page.	No.	Reference.
142	5	R 1157	154	34	F 6 r
142	6	G 96 v	155	35	F 8 r
142	7	T 12 r	155	36	F 34 v
142	8	Lu 1	155	37	G 34 r
143	9	Lu 33	156	38	F 85 v
146	10	E 8 v	156	39	S 136
146	11	R 1156	158	40	S 141
146	12	K 49 r	158	41	S 139
146	13	I 102 r, v	158	42	S 140
147	14	A 24 r	159	43	S 128
148	15	S 124	160	44	R 902
148	16	T 36 v	161	45	S 138
148	17	T 36 v	161	46	S 137

{201}

168	69	S 88		178	94	S 200
169	70	M 57 r		178	95	S 200
169	71	R 107		179	96	S 200
170	72	C A 337 v		179	97	R 1206
170	73	T 39 r		179	98	K 101 v
171	74	I 202		179	99	R 796
171	75	D 5 r		180	100	Lu 17
172	76	F 2 v		180	101	S 66
172	77	C A 75 v		181	102	S 122
172	78	H 67 v		181	103	R 1213
173	79	F 2 v		183	104	S 181
173	80	F 69 v		184	105	Ash III 27 v
174	81	S 129		185	106	S 192
174	82	C A 153 v		186	107	R 1214
174	83	V U 3 v		187	108	R 1215
175	84	R 984		187	109	C A 187 v
175	85	S 142		189	110	S 196
175	86	C A 76 r		189	111	B 4 V
176	87	C A 76 r				

www.ingramcontent.com/pod-product-compliance
Lightning Source LLC
Chambersburg PA
CBHW080616190526
45169CB00009B/3205